Painting Flowers
and Plants

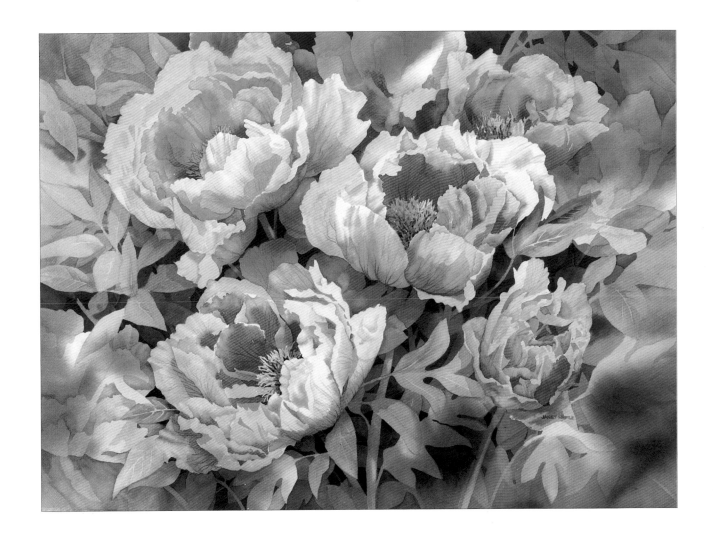

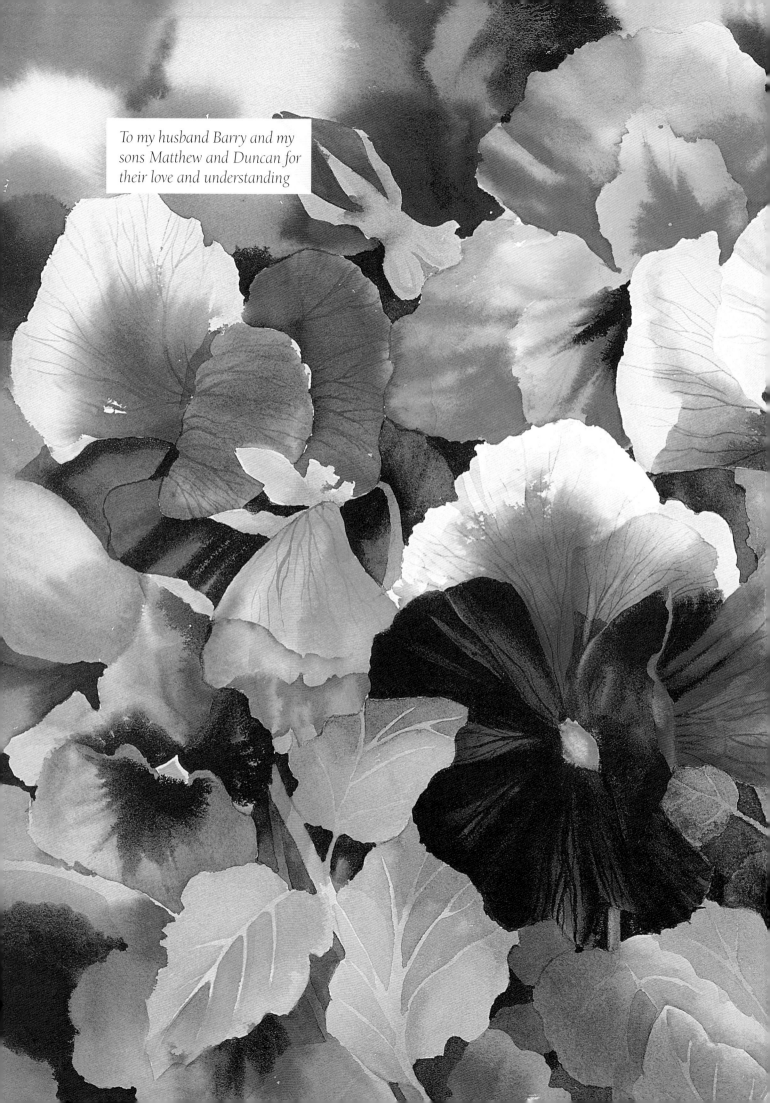

To my husband Barry and my sons Matthew and Duncan for their love and understanding

Painting Flowers
and Plants

J ANET W HITTLE

SEARCH PRESS

First published in Great Britain 2003

Search Press Limited
Wellwood, North Farm Road,
Tunbridge Wells, Kent TN2 3DR

Text copyright © Janet Whittle 2003

Photographs by Charlotte de la Bédoyère, Search Press Studios

Photographs and design copyright © Search Press Ltd. 2003

ISBN 1 9039 755 81

The Publishers and author can accept no responsibility for any consequences arising from the information, advice or instructions given in this publication.

Suppliers
If you have difficulty in obtaining any of the materials and equipment mentioned in this book, please visit the Search Press website for details of suppliers: www.searchpress.com

Alternatively, you can write to the Publishers at the address above, for a current list of stockists, including firms which operate a mail-order service, or you can write to Winsor and Newton requesting a list of distributors:

Winsor & Newton, UK Marketing,
Whitefriars Avenue, Harrow, Middlesex HA3 5RH.

Publishers' note
All the step-by-step photographs in this book feature the author, Janet Whittle, demonstrating how to paint flowers and plants in watercolour. No models have been used.

Printed in Spain by A. G. Elkar S. Coop. 48180 Loiu (Bizkaia)

I would like to thank, in alphabetical order, Caroline, for her words of wisdom; Hazel, for sharing and caring; Linda, for telling me I could write a book and how; Lindsay, for her support and encouragement, and Maureen for guidance when the direction wasn't clear. I would also like to thank all my colleagues and students past and present for their company and humour, and for making my working life as an artist so rich and rewarding. Special thanks to the team at Search Press for their encouragement and calm understanding.

Cover:
Himalayan Poppy *Meconopsis betonicifolia*
Size: 51 x 33cm (20 x 13in)
This lovely blue flower is one of my favourites (see also page 68)

Page 1:
Peony *Duchess of Marlborough*
Size: 51 x 33cm (20 x 13in)
This complex flower grows in a friend's garden, and I saw it in full bloom when conditions were absolutely perfect, just after the rain with the sun shining.

Pages 2/3:
Pansies
Size: 51 x 33cm (20 x 13in)
The stunning colour combination of blues and oranges in these pansies which I saw in a garden centre attracted me to paint them. I bought several trays and took them home.

Opposite:
Peony *Alba Plena*
Size: 51 x 33cm (20 x 13in)
I saw these in a garden in France. I had no time to paint them, so I took lots of reference photographs and used them to paint a simple composition which I felt suited the complexity of the flower.

Contents

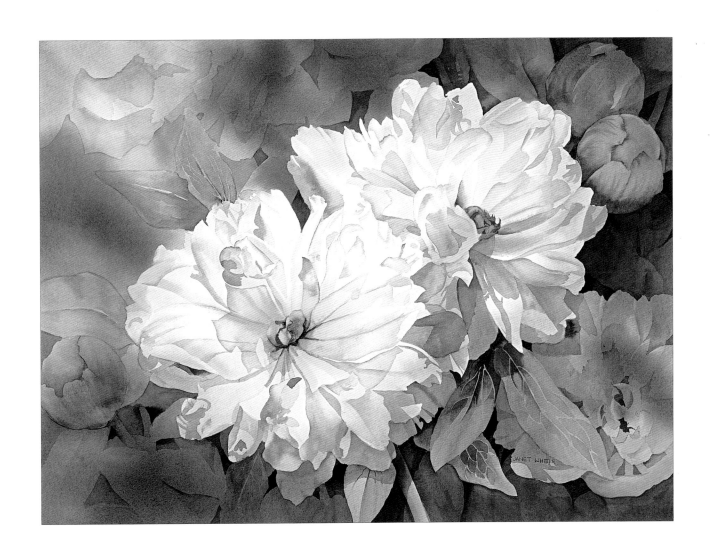

Introduction

Painting is like a journey which never brings you to a final destination. There is always something you have not yet painted, or a different colour or medium to try. The possible variations are endless, which is why I find it so exciting: it has kept me enthralled for twenty years.

Throughout my painting career, flowers have been one of my main inspirations. I never fail to be enchanted by the variety of colours and shapes, and the sheer perfection as the bud slowly unfolds to reveal the flower. As a painter, I have the freedom to portray them as I wish, using my imagination to change or combine colours and background tones.

I find the effects of sunlight and shadow magical. They can add an extra dimension to any painting, bringing out the colours, form and depth. I believe that it is only when you paint that you learn to observe closely enough to discover the significance of different light effects.

Every flower or plant is unique, and will respond to different techniques in different ways. Work through the exercises and practise any techniques you have not yet tried. Experiment with different approaches.

I have included some of my favourite techniques in this book. I hope you will find them useful and that, above all, you will enjoy trying them. It would take more than one lifetime to carry out every one on every flower, but I hope it will help you on your journey to improve your paintings.

Janet.

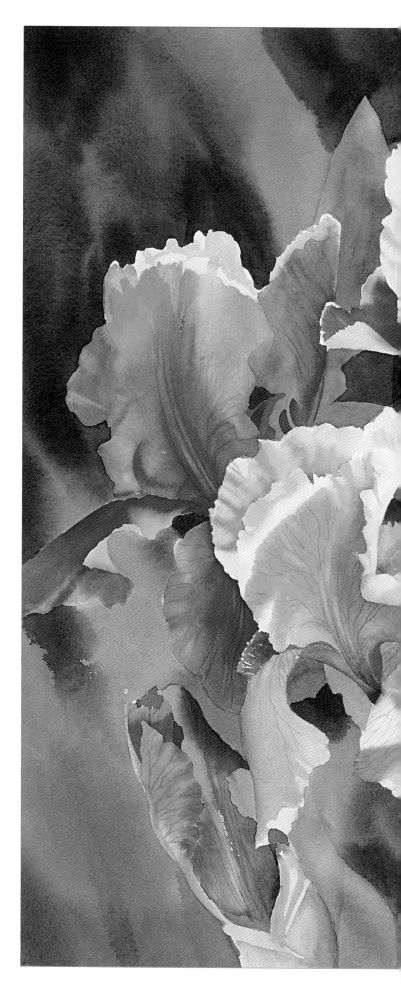

Irises
Size: 51 x 33cm (20 x 13in)
These irises do not flower for very long, so you have to watch the weather and take care not to miss the best of them.

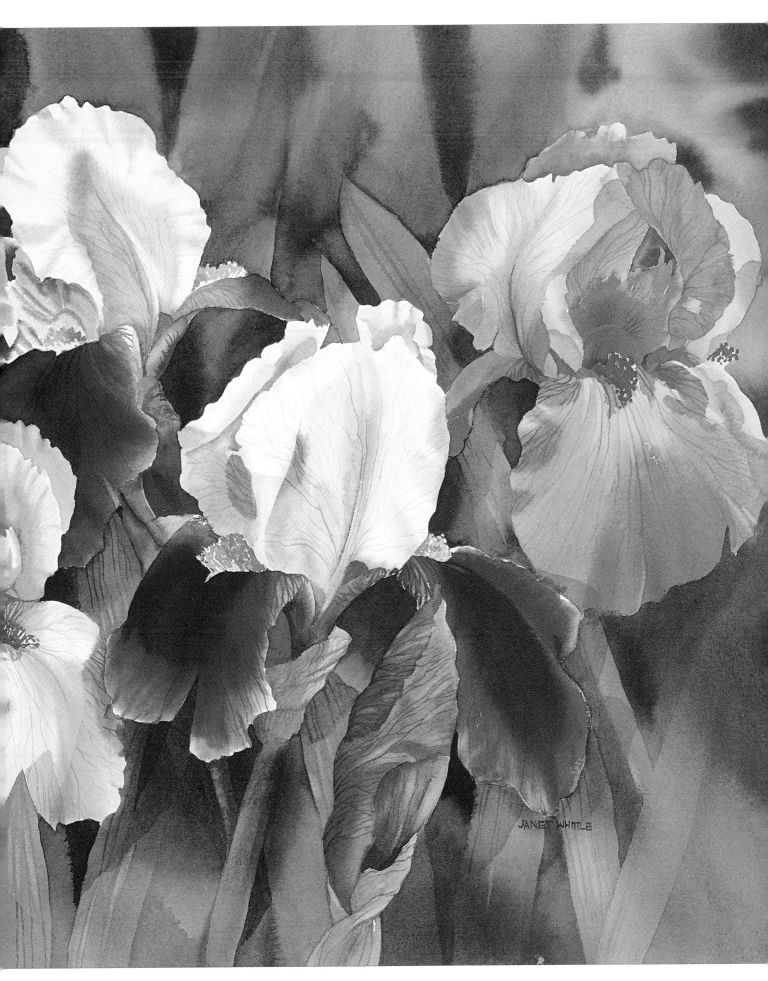

Materials

It is not necessary to collect all the items on these pages before you begin to paint: start with a few and add more as you go along. Starting out can be expensive: generally, the better the materials you buy, the longer they will last, and the easier it will be to master painting in the way you want. After all, you would not buy sandals if you wanted to take up jogging!

The essentials, obviously, are paper, brushes and paint. The colours and paper I use now are not necessarily the ones I shall be using next year. I am always trying to improve my painting and know I always will be. It is part of the excitement that keeps me painting, and I hope it will be the same for you.

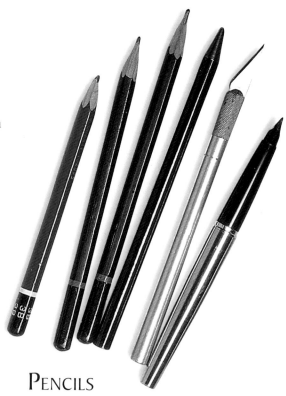

PAPER

They say a workman is only as good as his tools, and this is a good rule to follow when choosing paper. Do not buy job lots of cheap paper, or something left over from school, or bits of unidentifiable paper that you have had given to you or have found in a drawer.

Different papers have very different properties, and it is important to understand what your paper will or will not do as this will dictate the techniques you use for a painting. The most obvious distinction is the smoothness or roughness of the paper, which will affect the appearance of your painting. Some papers will take masking fluid, but it will lift the surface of others when you try to remove it. It is more difficult to work wet-in-wet with the more absorbent papers.

I have indicated the paper I have used for each demonstration. This is the one I enjoy working with, but it may not be the case for you. It pays to experiment, and it is also fun! I use 300gsm (140lb) or 640gsm (300lb) Not. If you use the lighter weight paper it should be stretched on a drawing board about 20cm (4in) larger than the size of the paper. Do not forget you will lose at least 5cm (1in) all round underneath the tape. For composition sketches, I use ordinary cartridge paper.

PENCILS

I use HB pencils for initial line drawings as they do not need to be too heavy. To draw in extra flowers after the initial washes, I use a 3B pencil, as this shows up over the colour and will not dent the paper like a harder pencil. For darks, or for transferring carbon to the back of a tracing, I use a 9B pencil.

FOUNTAIN PEN

I use a fountain pen to trace off an image, as pencil lines cannot be seen through carbon placed on a design. I use a ballpoint pen (not shown) when I am tracing off a design from carbon paper – see page 17.

SCALPEL

I use a scalpel or a penknife to sharpen lead pencils. For pure graphite pencils, I use a pencil sharpener.

A selection of watercolour papers, sketch books and a drawing board.

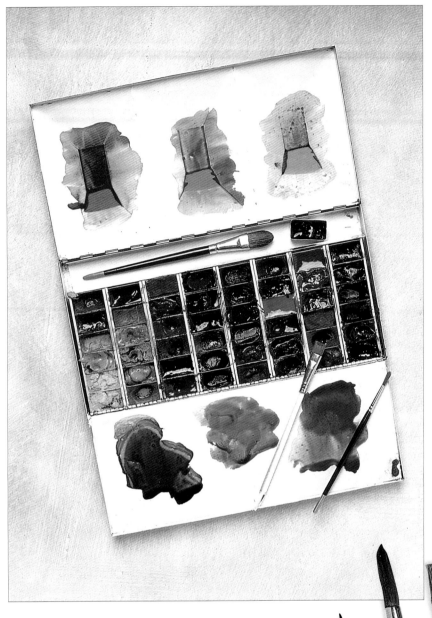

PAINTS

I use a variety of different makes and colours of paint, but I always choose artists' quality. These are brighter and soften easily, and though they are more expensive the effect is well worth it. Buy just a few colours to begin with, rather than starting with dozens of tubes or pans. This will help you to get to know the colour mixes well.

I am continually discovering new colours and mixes; it is part of the joy of painting. I fill up empty pans with paint straight from the tube.

BRUSHES

These are just a few from my collection of brushes, which are made from both natural and man-made fibre. I have no particular preference, though I like a firm brush and synthetic fibre does tend to be firmer as well as less expensive.

You will need a small (No. 00) round brush for details such as veining on petals and leaves, and Nos. 4, 6, and 8 round brushes for painting flowers. A small rigger (No. 3) is good for veining on larger paintings as it holds a lot of paint and does not need loading so often. I use a 13mm (½in) or 6mm (¼in) flat acrylic brush, which is a little firmer than a watercolour brush, for softening outlines and lifting out painted areas. The largest brush shown is a No. 6 wash brush. To wet backgrounds, I use a larger brush (not shown) – up to a No. 16.

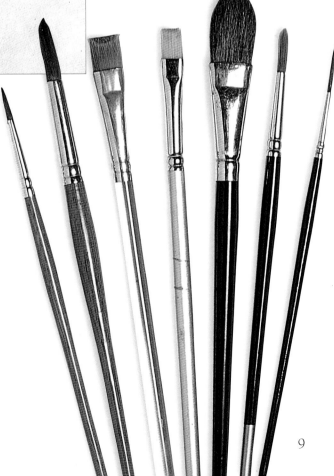

OTHER EQUIPMENT

Water container I use ordinary jam jars to hold water.

Scissors You will need a good sharp pair of scissors.

Pipette This is useful when mixing the larger first washes. They cost very little and make it easier to dilute a colour to the shade you require.

Pencil sharpener Use this to sharpen pure graphite pencils.

Masking fluid Use this to mask off areas of your painting – see page 30.

Old paintbrush Useful for applying masking fluid.

Dip pen Use this to apply masking fluid when you want fine detail.

Drawing pins I find these useful for attaching paper to a drawing board.

Rule or straight-edge Use this for measuring paper and for drawing a border for your painting.

Large soft brush Use this to brush away rubbed-off particles of masking fluid.

Plastic eraser I prefer this to a putty eraser as it is a little firmer, and never takes the surface off the paper. To erase small or fiddly areas, cut a small slice off the end of your eraser.

Paper towels Use these to adjust the moisture on brushes or to pick up droplets of paint or water.

Gummed paper strip Use this to attach lighter weight papers to your drawing board when stretching paper.

Methylated spirit Use this with a pad or piece of cotton wool to even out carbon used for a tracing.

Palette I use a white china palette for mixing colours. White is the best choice because you will be able to see the true colours, unchanged by any colour underneath. Some artists simply use large white china dinner plates or white plastic trays which you can obtain from hardware stores.

TIP

In hot weather, watercolour can be a difficult medium, especially when putting in large washes, as the heat makes them dry at different rates. Adding a few drops of ox gall fluid to your washes helps the flow and promotes even drying.

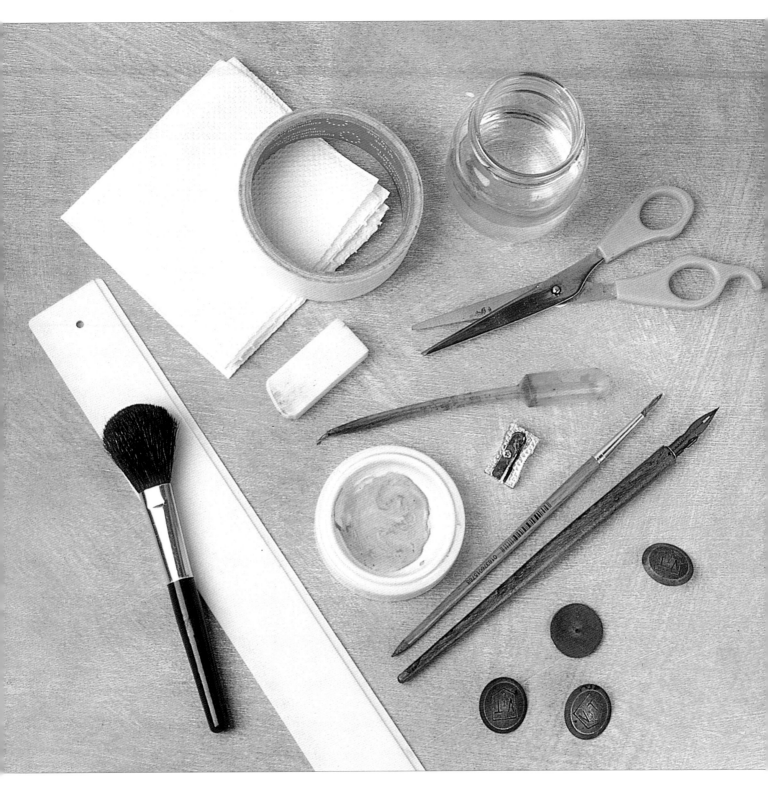

Not shown:

Hair dryer This can be used to speed up the drying process, but I feel that it can dull the colours a little, and may also make masking fluid sticky and more difficult to remove. If you do use one, make sure the shine has gone off your painting before you start or it will move the paint.

Spray mister This is ideal for softening pans of paint that have dried, or for spraying the paper to re-wet it if a wash has dried unevenly. Any empty domestic spray can be rinsed and filled with clean water (see also page 40).

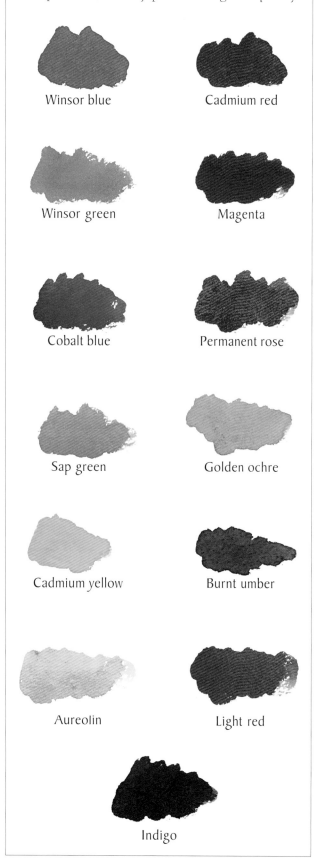

MY BASIC PALETTE

These are the colours I use at the moment, but I like to experiment, and my palette changes frequently.

Winsor blue

Cadmium red

Winsor green

Magenta

Cobalt blue

Permanent rose

Sap green

Golden ochre

Cadmium yellow

Burnt umber

Aureolin

Light red

Indigo

Using Colour

I have not included a colour wheel in this section because I find them deceptive. There are so many variations in makes and shades that they can bear little resemblance to those featured in a basic colour wheel. If you are a beginner, I have included a few basic mixes to start you off, which you should find useful. As you become familiar with them, you will begin to remember how they look.

When using colour, there are several stumbling blocks that students run up against. These include:

Not squirting out enough colour

Being mean with paint is a failing of which some of the most generous people I know are guilty. It is a standing joke with my students that you will not be given any sympathy if you were brought up during the war and are still suffering from 'rationing syndrome'. I regularly come across students who are desperately trying to extract the last remnants of paint from a dried-up tube, or vainly trying to moisten a hard lump of paint that has been on their palette for months. You are just going to have to brace yourself, give in gracefully and try to enjoy it.

Not mixing the colours brightly enough

When working wet-in-wet, as I do a great deal, remember that the colour will diffuse and spread, and that watercolour will dry lighter. The general rule is: 'If it's right when it's wet, then it's wrong!'

Not mixing enough paint

You will not have time to mix more paint while you are in the middle of applying a wash. Always mix more than you think you will need, and you are likely to find that you have mixed just the right amount. If there is some left over, it will not be wasted because you will need the colours throughout the painting.

Tulips
Size: 38 x 56cm (15 x 22in)
This vibrant painting uses shades from my basic palette including cadmium yellow, Winsor blue, cadmium red and permanent rose.

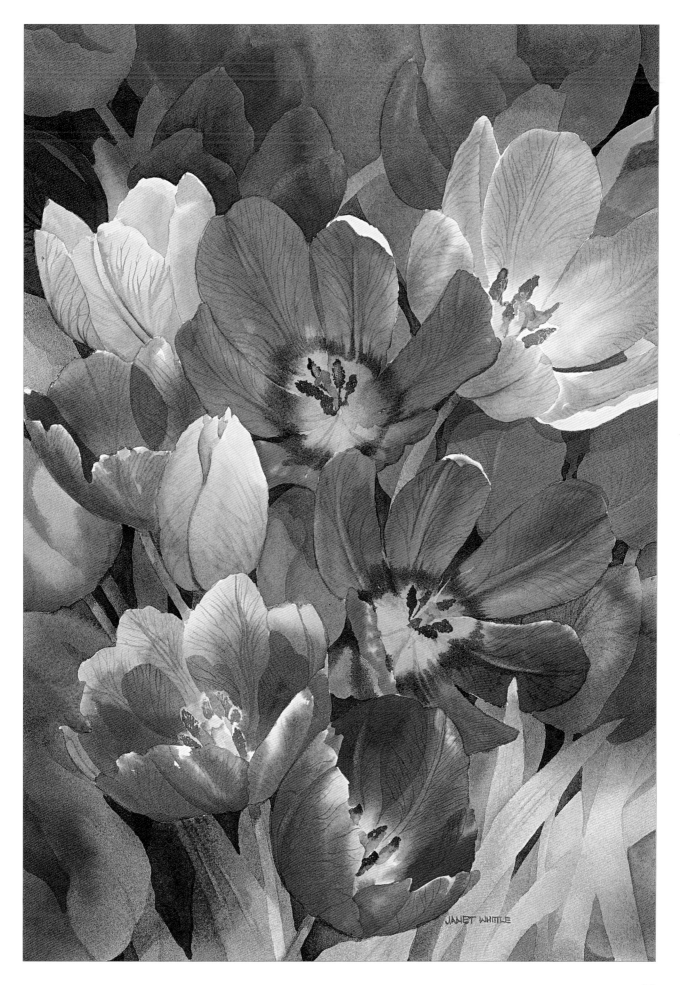

COLOUR MIXES

The basic palette on page 12 and the mixes shown below are the ones I am using at the moment, but I do like to experiment with different colours and my palette changes frequently. There are so many lovely colours available that I could not bear to use the same ones year after year. Part of the joy of painting is the excitement of choosing and trying out new colours.

I prefer to use mostly transparent colours, and much of the time I feel the brighter the better – as you will see from my paintings. I hope you will find these mixes useful. Most of them have been used in the step-by-step demonstrations, but do not let that stop you experimenting. I am always discovering new mixes and I hope you will too. The selection includes warm and cool mixes which are just as important for flowers as landscapes, a fact that is often overlooked.

BASIC MIXES

Permanent rose/aureolin
This lovely transparent orange/ salmon colour is useful for flowers including roses.

Golden ochre/Winsor blue
Unlike many greens, this good sage green will not dry dull and cold and spoil a lively painting.

Winsor blue/permanent rose
These mix a really vibrant purple that does not dry flat, and will mix on the paper wet-in-wet.

Viridian/Winsor blue/magenta
These intense colours mix a 'wonder dark' that never dries flat and dull.

Burnt umber/viridian
This rich olive green is useful for the darks in foliage and leaves, without being dull.

GREENS

Lemon yellow/viridian
This is good to retain brightness in first washes. Glazed back, it gives a glow to grasses and leaves.

Winsor blue/viridian
Many leaves are this turquoise green. It is a useful first wash where there is a shine to the leaf.

Cobalt blue/viridian
This gives a softer turquoise than the mix above, depending on the mood of your painting.

Cadmium yellow/Winsor blue
These colours mix a wide range of greens from bright to dark depending on the amounts used.

Cadmium yellow/viridian
A richer, warmer green mix than with lemon yellow. I like to vary greens from cool to warm.

EXTRA COLOURS

Transparent orange
For flowers and to warm foliage: there is a surprising amount of colour in grasses and leaves.

Red gold lake
This transparent golden colour can be used as a glaze to give depth to yellow flowers.

Purple
Endless variations are mixed with this versatile colour. Blues will cool it and permanent rose brighten it.

Cerulean blue
Mixed with cobalt or Winsor blue, this extends my range of blues for flowers such as meconopsis.

SHADOW MIXES

Cobalt blue/permanent rose
This soft lilac is more effective for shadows than mixes with black, which can dry flat and lifeless.

Cobalt blue/light red
I tend to use this warm grey mix biased towards blue as light red can be a dominant colour.

Cabbage White on Syringa Blossom

Size: 38 x 56cm (15 x 22in)
Using a limited palette makes you explore one colour and take it to its limits without being sidetracked by different colours. I used the whole tonal range from white to darkest green to give the depth needed.

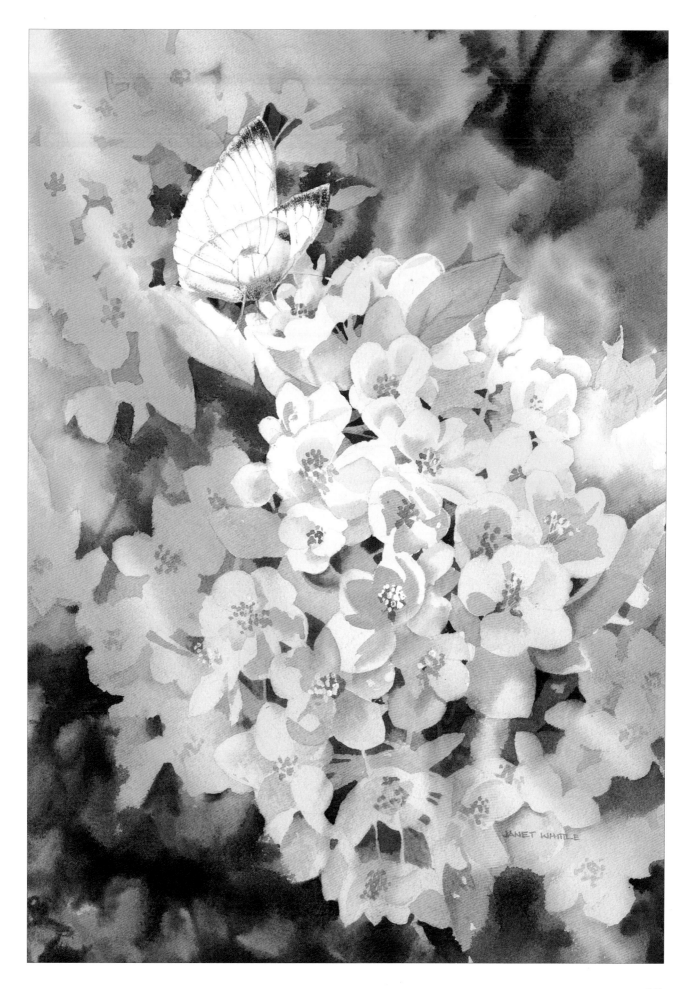

Before you begin...

I usually stretch all my paper, with the exception of 640gsm (300lb). Sometimes I even stretch this, but perhaps I was born a pessimist! The wet-in-wet washes I use can cockle the paper, and this will always show under a mount.

There are ways to flatten paper after it has been painted on, but I feel they are fraught with more problems than they are worth. The heavier the paper the less likely it is to cockle, as long as the washes are not too wet. I find that the painting which cockles the worst is *always* the best one you have done in a long while, and you will often regret not having taken the trouble to stretch the paper. The choice is yours!

STRETCHING PAPER

When you are stretching paper, the heavier the weight of paper the longer it will need to be immersed in water. For example, 190gsm (90lb) will need only around two minutes but 640gsm (300lb) will need three or four minutes. Take care not to soak the paper for too long though, as this will change the way it reacts to your washes and may cause problems.

You will need a drawing board, the paper you want to stretch and some gummed brown paper strip 38-50mm (1½–2in) wide. Make sure your drawing board is approximately 10cm (4in) larger all round than the paper. The whole sheet of paper must be immersed or it will be unevenly soaked. I find the best way is to run a shallow bath and immerse several sheets at once, but remember that you will need a drawing board for every piece of paper.

When the paper is soaked, remove it from the water and tip it to one side to allow the excess to run off. Lay it on your drawing board and pat it with absorbent paper, or a tea towel, to remove the shine. Tear off four strips of gummed tape a little longer than the sides of your paper. Draw them through the water one at a time, removing the excess water by running the strip through your fingers.

Lay the first strip half on the drawing board and half on the paper to fix it down, and smooth it lightly to remove air bubbles. Repeat on all four sides. To provide more stability when using a very large sheet of paper, drawing pins can be used over the top of the tape in each of the four corners.

Leave the board to dry flat: this is important because if you stand it up, the water will drain to the bottom and the paper will dry unevenly, increasing the chances of it pulling away from the tape.

When the painting is finished, you can remove it from the board by slitting between the paper and brown tape.

TIP

Make sure the strips of brown paper are fixed evenly to your drawing board: if one side is stronger it may pull away from the others.

If you find your paper is not fixed evenly, all is not lost: soak or cut it off and start again.

TRANSFERRING DESIGNS

YOU WILL NEED

Tracing paper
A pen with black ink
Soft pencil (9B)
Methylated spirit
Cotton wool pad
Watercolour paper
Masking tape
Ballpoint pen

Making transfer paper

Making your own tracing-down paper is easy, and allows you to transfer your own designs or sketches to watercolour paper. I use a fountain pen to trace the design but a black felt-tip pen is fine too. Methylated spirit is used to 'scumble' the pencil marks, which sets the graphite and covers the back of the design evenly with carbon. The advantages of this method are that the tracing-down paper can be used many times. If you are not happy with your first painting you will not have to start completely from scratch, so I feel this will give you more confidence.

If you want to make sure your design does not slip while you are transferring it to your watercolour paper, lay the tracing-down paper on the paper you have drawn your design on and attach it to the top with 'hinges' of masking tape.

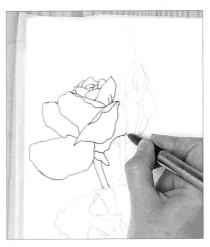

1 Lay the tracing paper over your design and trace it using a fountain pen and black ink.

2 Turn the tracing paper over and use a soft pencil (9B) to scribble evenly over the back of the design.

3 With a cotton wool pad and a small amount of methylated spirit, 'scumble' the pencil marks. Leave it to dry.

4 Turn the tracing paper over and lay it on your watercolour paper, fixing it with hinges of masking tape. Use a ballpoint pen to trace the design.

5 Check to make sure that the design has come through before removing the tape hinges. If necessary, replace them and re-trace any areas that are too faint, adding more carbon if necessary.

NOTE

1. If the tracing paper moves or the hinges of tape come off, stick the point of a pin in a recognisable place, such as the intersection of two lines. Then put the point of the pin in the same spot in your unfinished tracing and realign it. Re-attach the tape hinges.

The design shown in these steps is for the rose painting – see page 27

Using photocopies

The simplest way of transferring a design is by using a photocopy of something you like. The advantage of this method is that it can be enlarged or reduced to suit the size of painting you wish to produce.

To transfer a design using a photocopy, scribble in soft pencil on the back of the photocopy and transfer the image (see page 17). You cannot use methylated spirit to even out and 'set' the pencil marks, so take care not to lean on your work or the graphite may rub off and make your paper grey.

You can also make a plain carbon to use between the photocopy and your watercolour paper. Do this by scribbling on tracing paper with a soft pencil (9B) and 'scumbling' with methylated spirits as on page 17.

Using a grid

A grid is another effective way to transfer a design to watercolour paper. Divide your original drawing or sketch into quarters or eighths (depending on the size) and copy one square at a time on to your paper. Erase the pencilled grid lines before you begin to paint as they can be confusing.

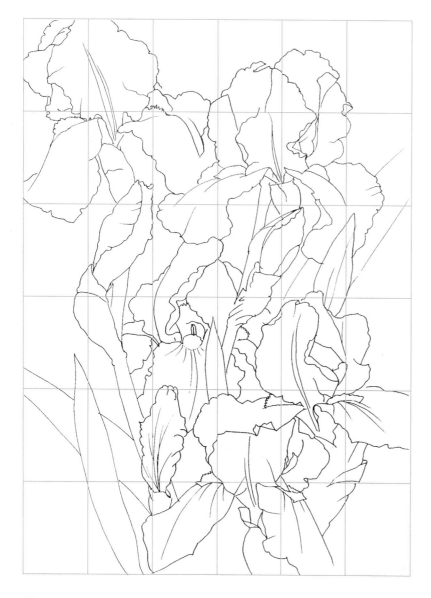

Irises

Size: 38 x 56cm (15 x 22in)
These irises were white, but as previously mentioned, the amount of white in apparently white flowers is often very little! I used quite a vibrant purple/violet for the shadows and tonal values, and also dropped it in to the background to unite the painting. Softer shapes of flowers have been cut out to give it depth. As purple and orange are complementary colours, these were emphasised as much as possible for effect. To give the painting vitality, the focal flowers were counterchanged towards the centre by placing the darkest darks against the lightest lights.

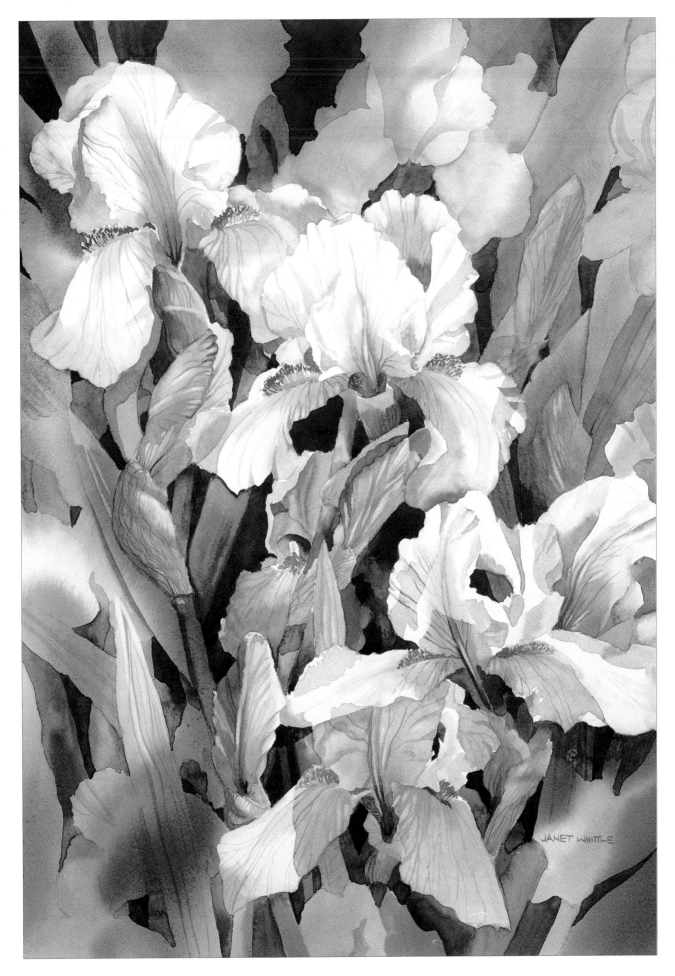

Drawing

When I have not painted a particular flower before, I always find it helpful to do a detailed drawing before I start to paint so I can familiarise myself with the flower, its form and shape, and how it grows. If, when I come to paint, the flower is no longer in bloom or there are gaps in my reference material, this information can be used to bridge any gaps. Drawing is more controllable than painting because you can erase, so it will help to build your confidence.

I usually start with a simple line drawing of the composition, like the ones shown at the beginning of the demonstrations in this book. I keep the line light and put in the first tone, leaving white for highlights. In the real world there are very few actual lines, just changes in tone, so it is important to dispense with lines and learn to shade these changes of tone as soon as possible. When I am drawing, I gradually work darker using a 3B or 4B pencil, going over some of the lighter tone and feathering it in.

I prefer to work over my whole drawing rather than finishing one part and moving on to the next because I think it helps to pull everything together. I put in the darks to give depth to the composition using a 9B pencil. Make sure that you place the darkest darks against the lightest lights, a process known as counterchanging.

If you want a particular part of a drawing or painting to appear to come forward or show up, darken behind it. Beginners often outline aspects of a drawing or painting hoping to achieve this, but all it does is make the flower look heavy. In the drawing of the iris (right) I have darkened the stem beneath the front petal so the effect is that it is coming towards you.

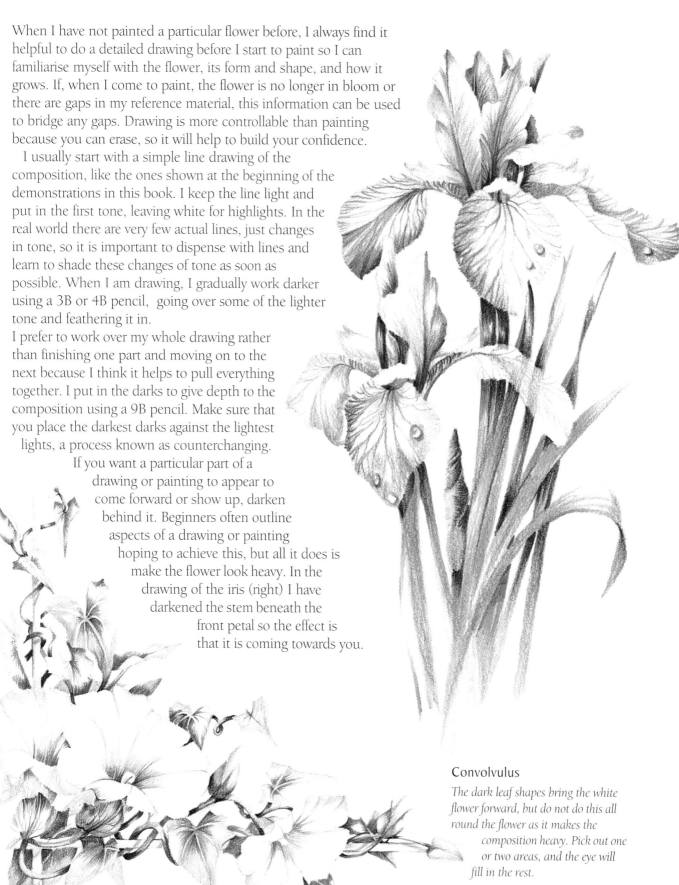

Convolvulus

The dark leaf shapes bring the white flower forward, but do not do this all round the flower as it makes the composition heavy. Pick out one or two areas, and the eye will fill in the rest.

Tulips

Size 33 x 33cm (13 x 13in)
Drawing and painting in the same composition is a lovely and very effective technique. A smooth paper (cold-pressed) has been used here as it is easier to draw on. I make a preliminary sketch, draw in a circle and mask out beyond it using masking fluid. When the painting is dry, I remove the masking fluid, then complete the drawing with a variety of pencils.

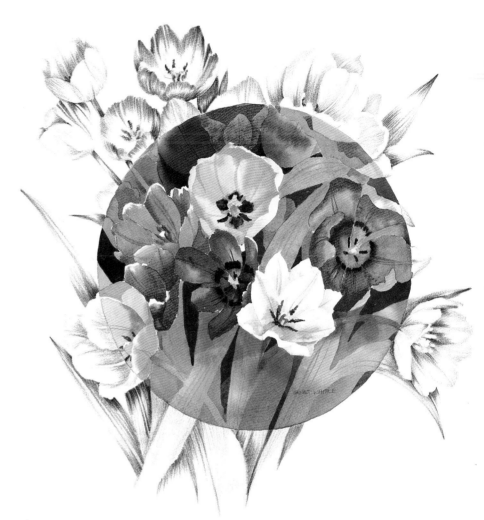

Daffodils

Size 33 x 33cm (13 x 13in)
This painting uses the same paper and technique as for Tulips (above). A set of paintings using the same technique but different subjects can be appealing. You might also like to try varying the shape behind the flowers, using a square or an oval.

21

My drawing

I find that if a composition does not work in pencil it does not work in paint. Drawing a flower helps me to understand the form, and I can experiment with composition because errors can be erased easily. When I come to do the painting I am halfway there.

This drawing was done on cartridge paper using an HB pencil for the outline, then a mixture of HB, 3B, 6B and 9B pencils. I put in the darks last. The drawing was then traced, and the original drawing was used as a tonal guide for the painting.

When I have finished a drawing I usually spray it with fixative to stop any smudging. This does not prevent me from adding more pencil later if I think it is necessary.

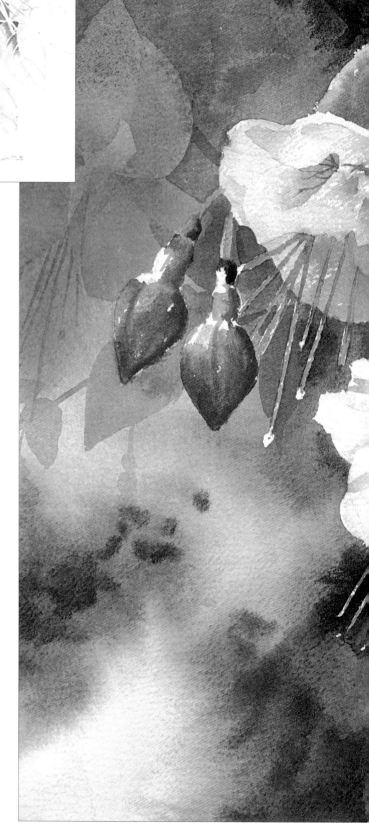

Fuchsia

Size: 38 x 56cm (15 x 22in)
This was done on 640gsm (300lb) Not paper using the drawing as a guide. The main flowers were masked and a mixture of greens, blues and pinks were dropped into the background. The leaves were brought forward with negative painting – see page 42. The flowers were painted last, using the blues from the background to shadow the white petals, and a mixture of permanent rose, cadmium red and cadmium yellow for the other petals.

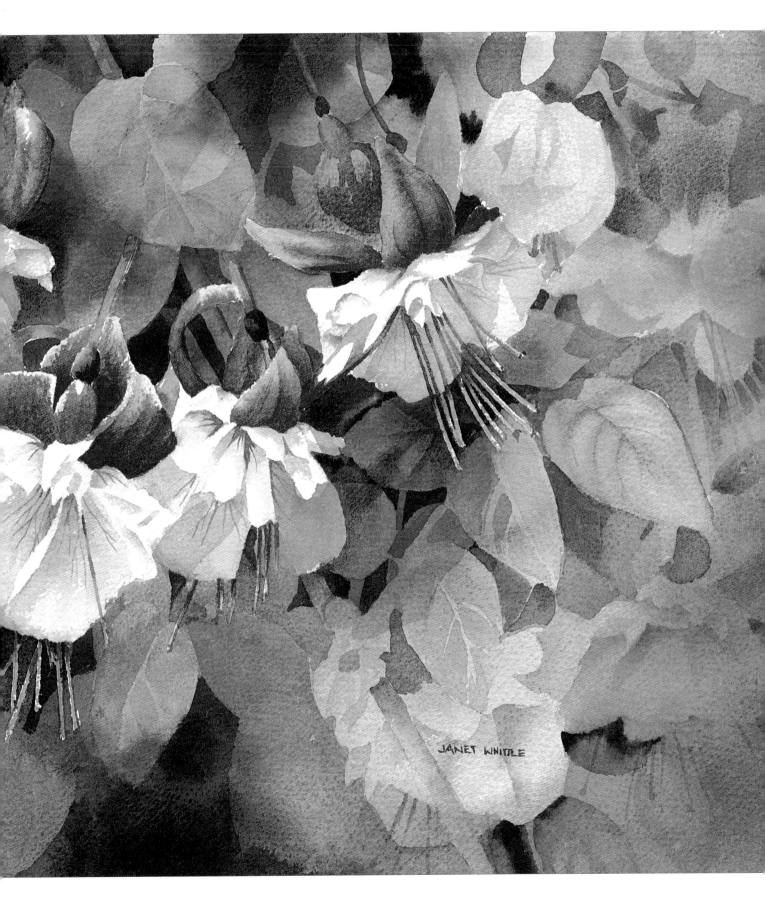

Composition

It is important to spend time on composition before you start to paint. The less experience you have, the more you will need to plan ahead. Not all artists draw first, but those who are brave enough not to are those with the experience to keep the basic composition in their heads and adjust elements as they go along. I find that producing one or two thumbnail sketches before I begin to paint is usually enough to inspire me.

This list may help to organise your thoughts:

1. If you are not painting from life, collect together all the reference material you have on the type of flower or flowers you wish to paint.

2. Decide what type of paper and what shape of painting – for example, portrait, landscape or letter box – suits your subject best.

3. Make thumbnail sketches to decide the position of the main flowers.

4. Draw a border to contain your composition: it makes it easier to visualise.

5. Remember to interlock some shapes to avoid a 'hole' in the middle of your composition.

6. Vary the size of different elements of your painting, taking care to include buds, half- and fully-opened flowers, and different sized leaves. If all elements are the same size the effect will be like wallpaper.

7. Draw your design, either by tracing it from cartridge paper to watercolour paper or, as your confidence grows, straight on to the paper.

8. Decide the direction of the light and stick to it throughout your painting. Your finished painting will look extremely odd if you have light coming from different directions.

9. Mask out areas where appropriate.

10. Choose your palette, and remember artistic licence means you can change the colour of the flowers and the background if you want to.

11. Think beautiful thoughts!

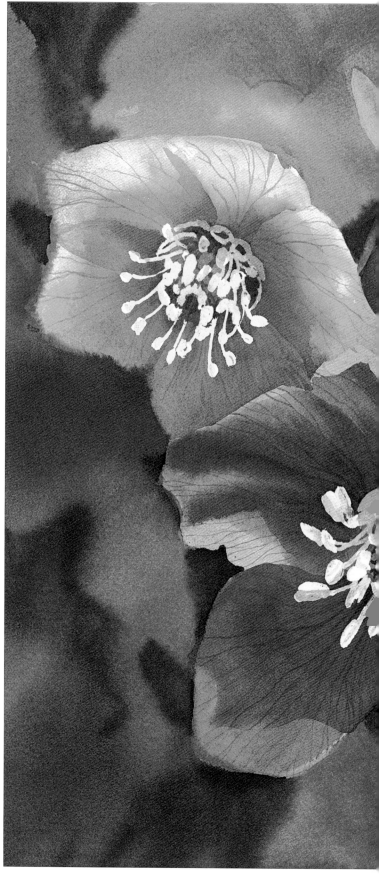

Hellebores
Size: 55 x 38cm (21½ x 15in)
Permanent rose was used underneath to give a glow to the darker colour of the flowers. The stamens were masked and painted last.

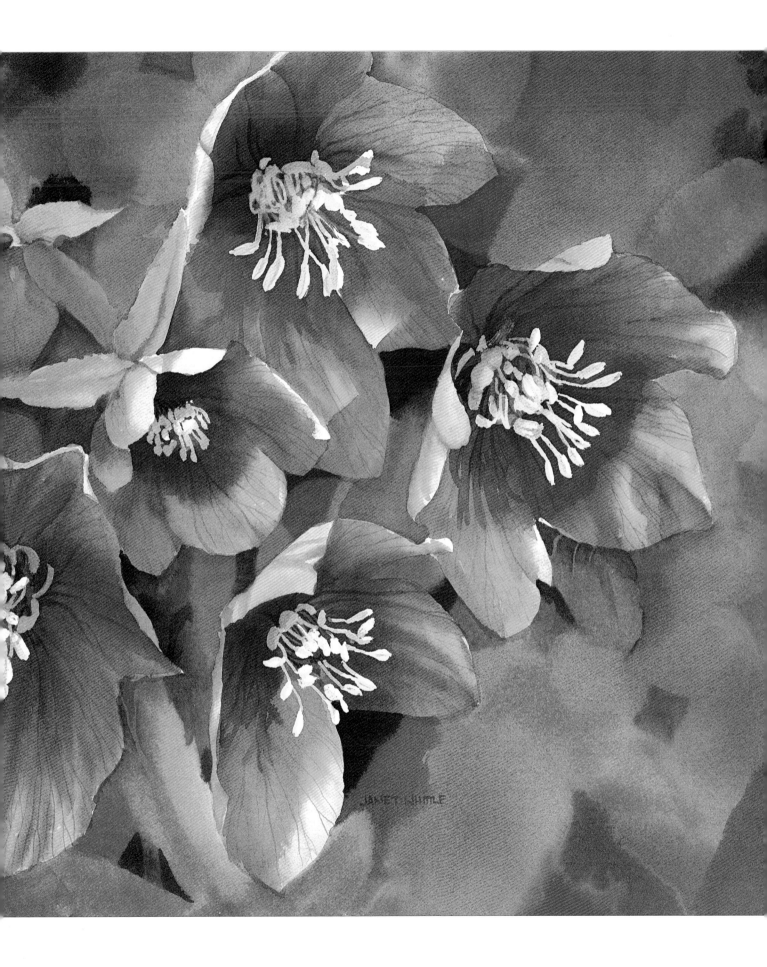

USING PHOTOGRAPHS

I paint mainly from life, but I find photographs invaluable. In an ideal world, flowers would not wilt or die until you had finished painting them, and the sun would shine all the time. As this is not the case, good reference photographs can be a real asset when you want to paint intricate flowers.

In flower painting, as with landscapes, the direction of light must be consistent or the result will be confused. When you take reference photographs, make sure the subject is lit from the same direction in each. Try to capture the flowers from all angles and at all stages of development so you have the best possible scope for your composition. To aid your memory, take a few good close-ups of details. I file my photographs in boxes in alphabetical order so they are easy to find.

The example opposite shows how the best aspects of two photographs can be used to produce a study, not a slavish copy. The background is a very simple vignette, and the leaves are painted dark against light.

My source photographs

Vignette

To do this, just wet the area of the paper where you want paint to go. You are in control because the paint will only go where you have used water. Draw your composition with an HB pencil, mask out the main flowers if you wish, and wet the background up to the masking but leaving a broken edge. Drop the paint in and tip the board so it flows into the shapes you have made with the clear water.

TIP

I try to make sure my reference photographs are taken when the sun is shining and that in each photograph the sun is coming from the same direction.

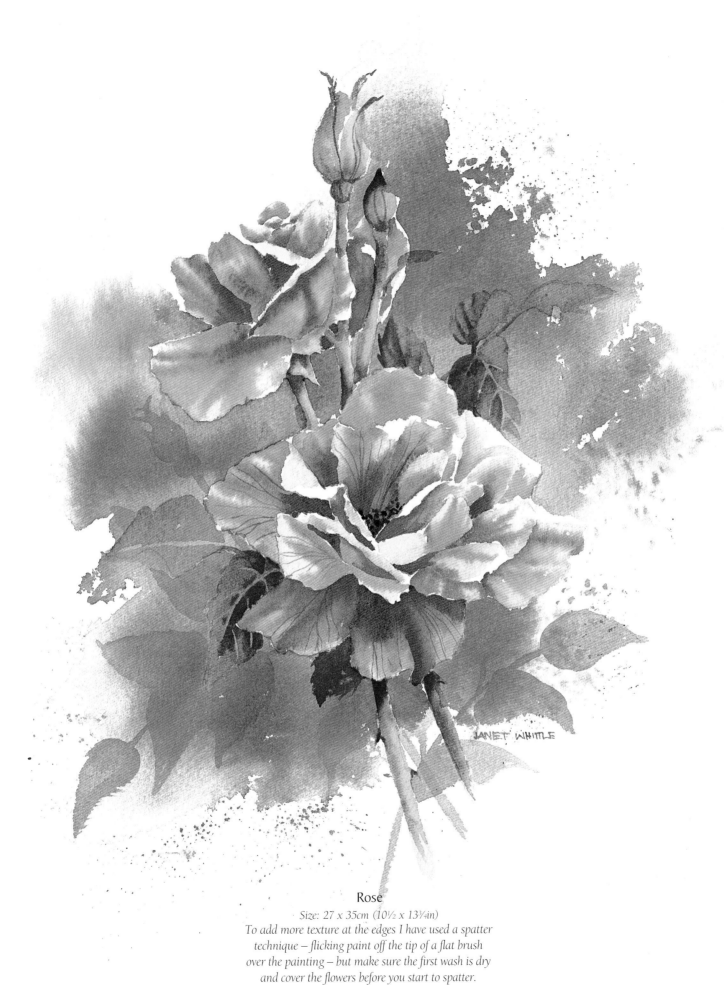

Rose

Size: 27 x 35cm (10½ x 13¾in)
To add more texture at the edges I have used a spatter
technique – flicking paint off the tip of a flat brush
over the painting – but make sure the first wash is dry
and cover the flowers before you start to spatter.

Techniques

As you become more experienced with different watercolour techniques, it is a common mistake to try to incorporate too many in a painting. Different approaches suit different flowers, so you should try to imagine how your subject would look best, and use the most suitable technique to enable you to achieve the effect. I have included the techniques I use most so you can practise and decide for yourself. I hope you enjoy it.

PUTTING IN A BACKGROUND

This exercise is extremely good practice, and there are no hard-and-fast rules: it starts with just an idea that you have in your head. Imagine the colours of the flowers, leaves and sunlight. Mix the colours you have imagined, wet the paper and drop them in. Tip the board to let the colours merge and leave it to dry, or wait until the shine has gone off and dry your work with a hair dryer.

Next, use the shapes that have settled in your wash and draw your composition on top, making the most of happy accidents: every wash will be different! The next step is to paint the negative shapes behind the flowers in a slightly darker tone, just to 'find' your composition. If any of the colours are not what you want, you can change them by glazing other transparent colours over the top (see page 48).

I have taken you step-by-step through this exciting technique in the following pages, with projects that give you plenty of practice putting in backgrounds and using masking fluid.

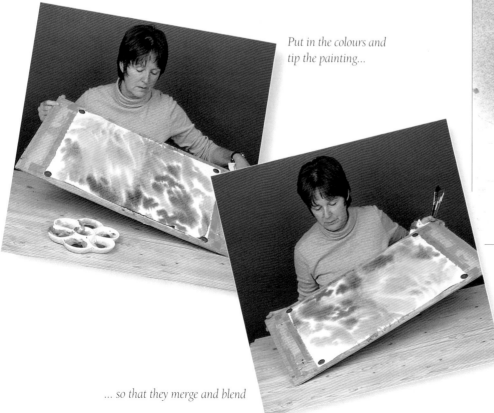

Put in the colours and tip the painting...

... so that they merge and blend

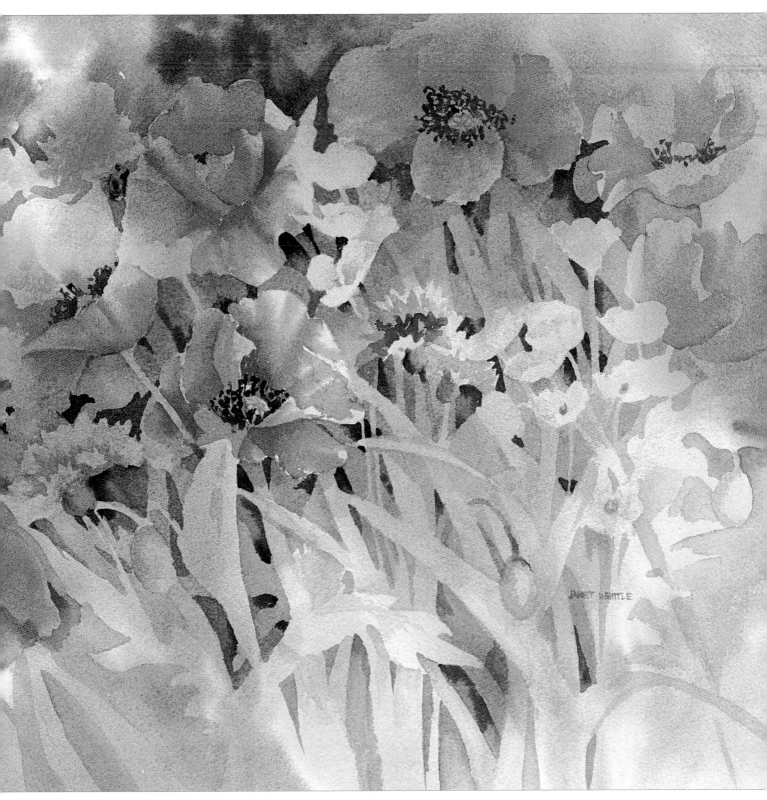

Poppies

Size: 55 x 38cm (21½ x 15in)

For the background of this painting, I used an approach that is great fun. I did not draw a composition on the paper before I began, but just flooded in the colours of the flowers and foliage. I tipped my drawing board so the colours merged and blended in the usual way, then let it all dry to see how they settled on the page. Then I drew the composition on top of the wash. This is really good practice for negative painting, because you paint behind the flowers, stalks and leaves to make them appear.

MASKING FLUID

Some masking fluid lifts off the colours underneath, so it is a good idea to experiment with different makes. Use a dip pen or an old brush and work a little neat soap into it first so the masking washes out easily.

If you want to use masking fluid with a pen to produce narrow lines (see page 35) but it seems too thick, it can usually be diluted with a few drops of water. Masking fluid can also be used over a first wash, so that when you rub it off the paper underneath is already coloured. Try this over a blue wash when you are painting bluebells. If you find it difficult to see the masking fluid against the paper, mix in a small quantity of either ultramarine blue or cobalt blue as these colours will not stain the paper.

Cow parsley with masking fluid

This exercise can be done with very little drawing, and is good practice for putting in backgrounds and using masking fluid. As the flower is white, you can use any colours you choose for the background. This technique is useful for flowers which have tiny florets, including forget-me-nots: masking fluid can be used over an initial wash and another wash can be added over the top. The butterfly can be used to add interest to any painting. I used the photographs below to help with the composition and detail.

YOU WILL NEED

Watercolour paper: use any weight but stretch lighter weight papers
Watercolour paints of your choice: see the colours I used opposite
Round brush No. 8
Flat brush 13mm (½in)
Small brush No. 00
3B pencil
Masking fluid and dip pen or old brush

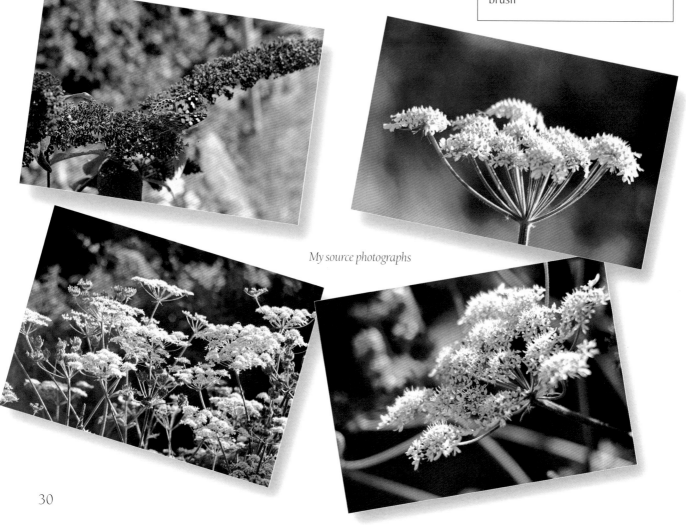

My source photographs

Mix the colours you want to use. For this demonstration, I used cadmium red, lemon yellow, cobalt blue and sap green, and a dark mix of burnt umber and Winsor blue for the details on the butterfly.

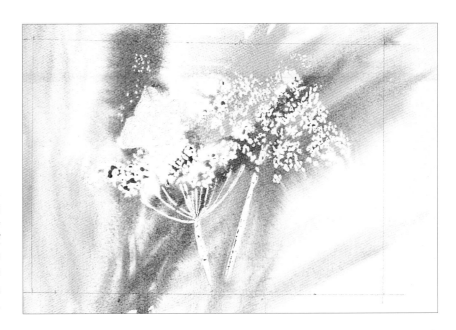

1 Pencil in a border and lightly draw in the shape of the cow parsley. Mask out the flower heads, stalks and the butterfly outline and let it dry. Wet the whole of the paper and, using the flat brush, drop in the yellow, blue and green. Tip the paper to merge the colours. When you are happy with the effect, leave to dry.

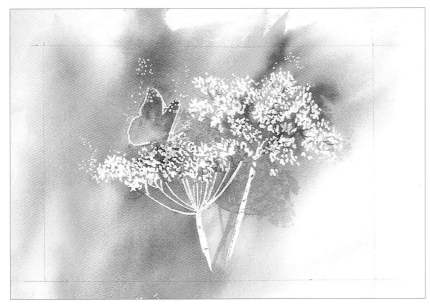

2 When the first washes are dry, paint the background shadow of the cow parsley using the No. 8 round brush and blue. Mask out the tiny white dots on the wings of the butterfly, allow it to dry and put in a red wash over the top. Leave your work to dry.

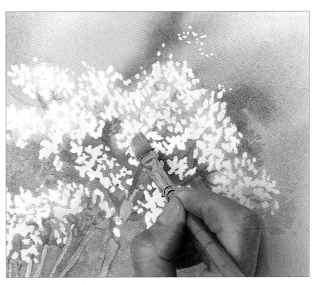

3 Remove the masking on the stalks and put a wash of pale green, with highlights in yellow, over them.

4 Remove the masking fluid from the flowers and add a wash of lemon yellow to some of them, varying the tones.

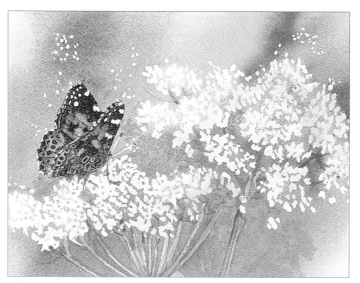

5 Stipple in the dark areas of the butterfly using a mix of burnt umber and Winsor blue. Use the point of a small brush (No. 00) to paint the colour in small dots, which gives the effect of a subtle blend of colour rather than a hard edge.

6 Allow your work to dry. If you want to add any extra flecks of white to the background or butterfly wings, they can be scraped out with the tip of a scalpel.

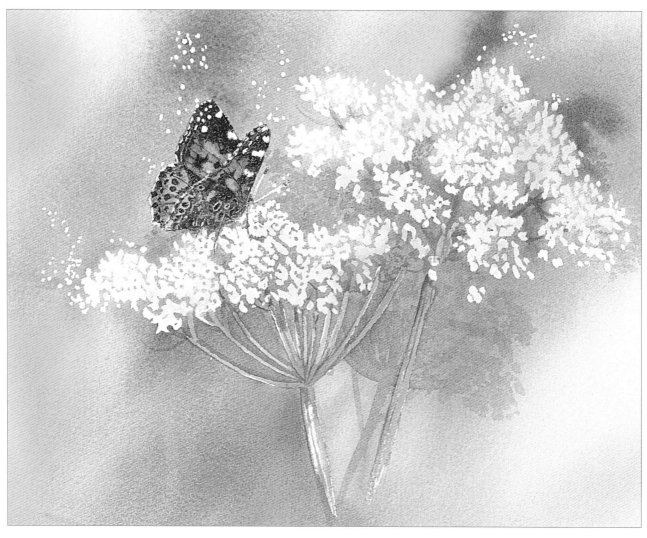

The finished painting

Butterflies

To add an extra touch of colour and interest to paintings, butterflies are ideal. The technique is easy, and you can practise different butterflies on odd pieces of watercolour paper. Mask out the outline and any white areas carefully and put in a simple wash of the main colour, for example red or yellow. Allow your work to dry, then put in the dark areas, stippling the paint in fine dots with the point of a small brush.

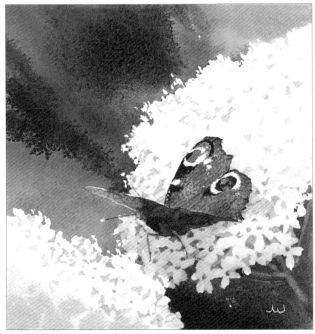

Peacock butterfly on cow parsley

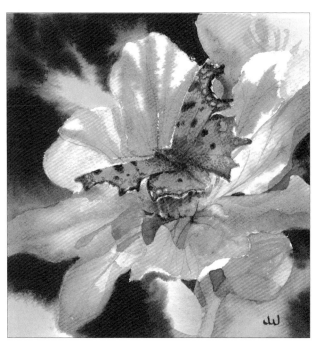

Comma butterfly on a dahlia

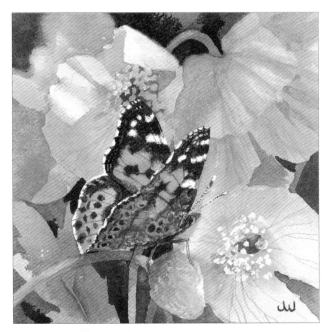

Painted lady on Welsh poppies

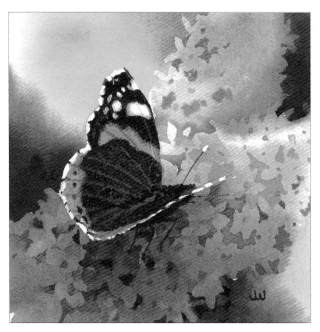

Red Admiral butterfly on buddleia

Spider's web

This is really just a background, painted following the method shown on page 28, plus some masking fluid. A cobweb can make a stunning addition to flower paintings.

You can use any colours you like for this practice piece as you will not be adding flowers this time – part of the fun is seeing how it turns out! Draw the cobweb on your paper first. Reference photographs will help with this, but as every web is unique, you can use your imagination!

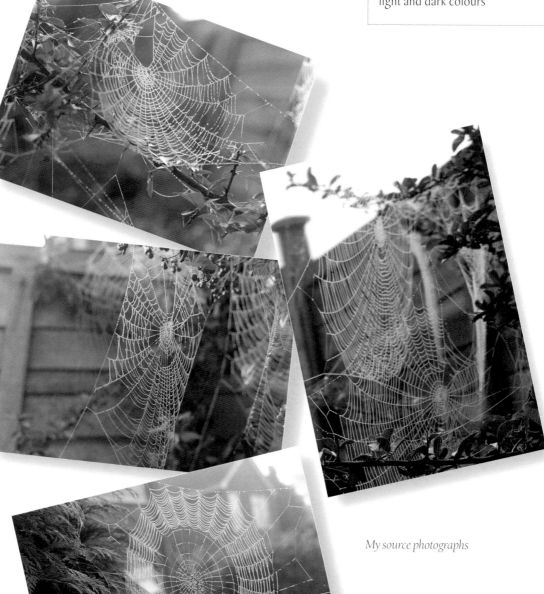

My source photographs

TIP

If you cannot find a flower or cobweb to photograph that still has the dew on it, use a spray mister to make it show up.

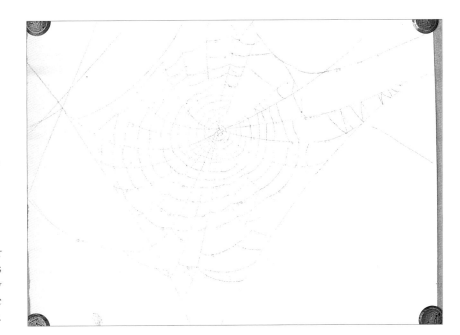

1 Pin or stretch your paper to your drawing board and draw a spider's web. Remember that the weight of dew pulls the threads down, so curve the lines gently.

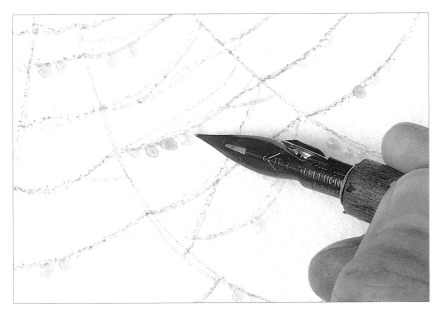

2 Go over the outlines of your drawing with masking fluid, using a dip pen or small brush, letting it form blobs of varying sizes to represent dew.

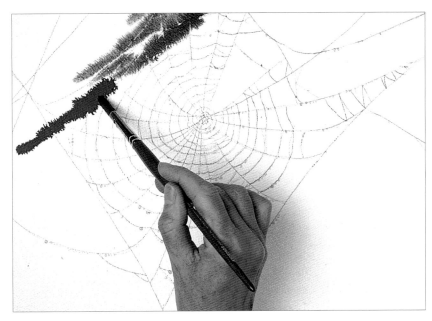

3 Mix the colours you want to use, then dampen the paper with a mister or brush. Begin to put on the paint, using a No. 7 brush, over the masking fluid as if you were just painting a background.

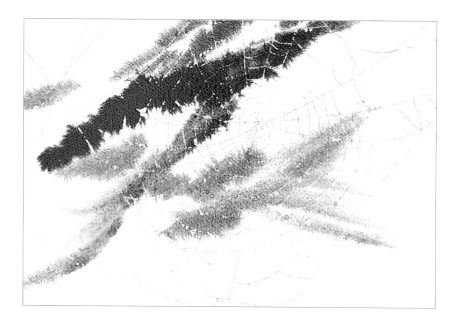

4 Build up the colour, painting gently so you do not lift the masking fluid lines off the paper.

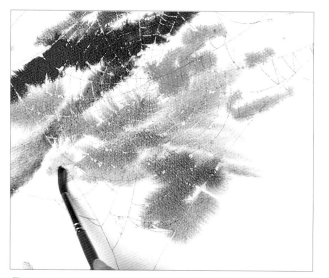

5 Add in some bright tones.

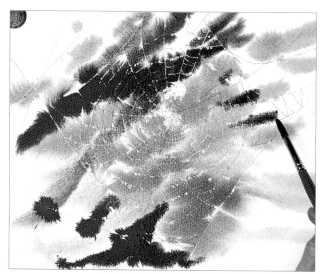

6 Put in some darker tones.

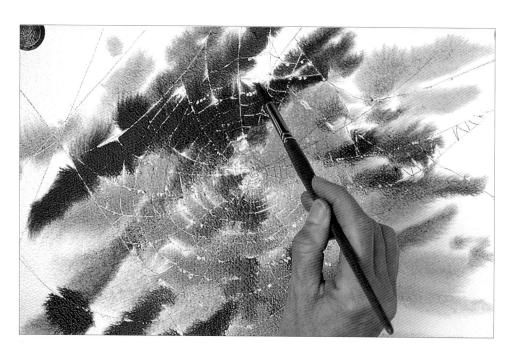

7 Push the paint gently over the masking fluid lines so there are no gaps.

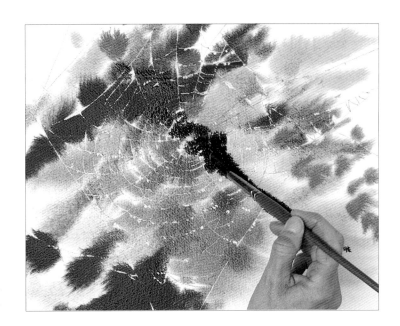

8 Finally, drop in some very dark tones,
and tip the board to blend the colours.

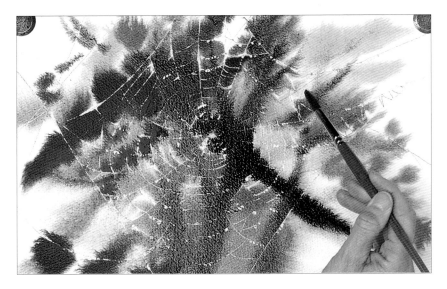

9 When the paper begins to dry, stop
adding paint or the colours will not
blend properly.

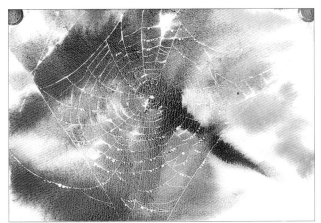

10 Tip your painting to merge the
colours. Leave your work to dry,

11 Remove the masking fluid and paint in
the dewdrops using a pale wash of cobalt
blue, leaving a small highlight on each.

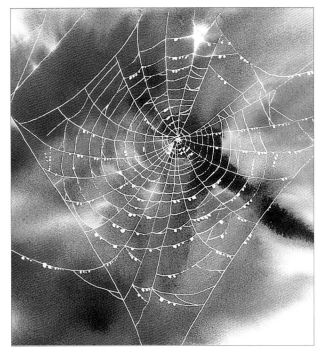

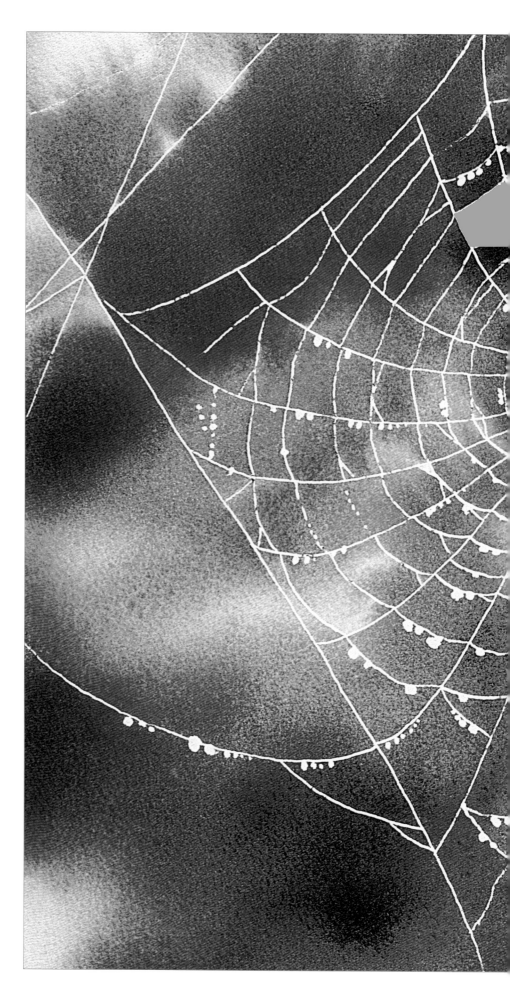

Spider's Web
Size: 28 x 38cm (11 x 15in).
Some areas of the web have been glazed
using cobalt blue, and some using lemon
yellow. Other areas have been left white as
though the sun is catching the web.

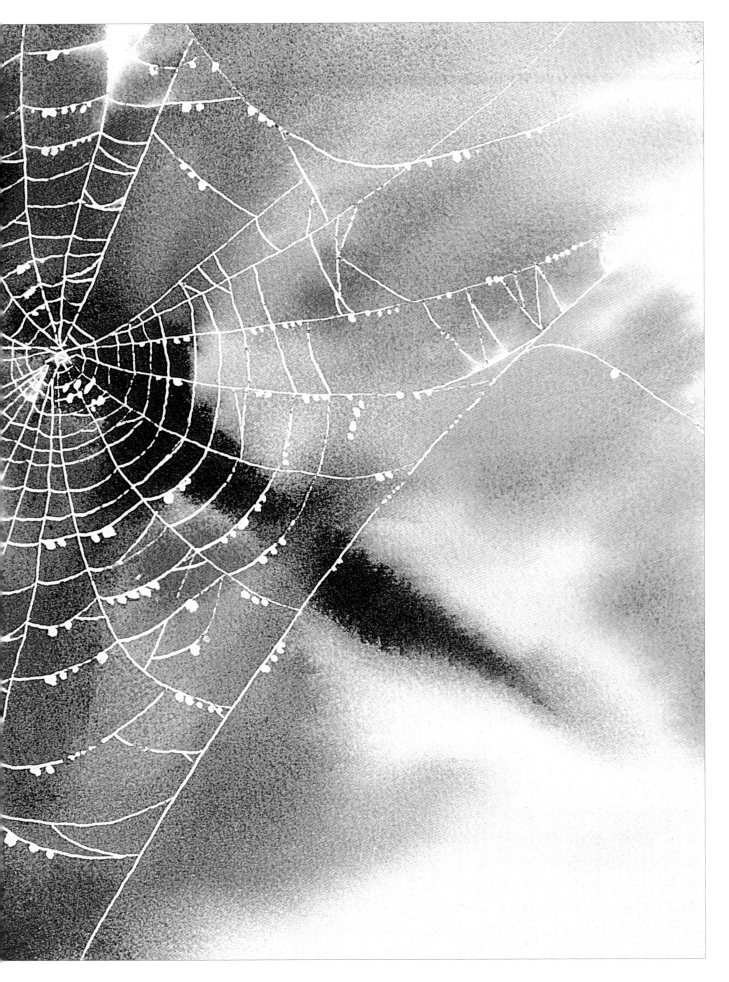

WET-IN-WET AND WET-ON-DRY

This exercise combines wet-in-wet and wet-on-dry, the techniques I use most. Mask the three main flowers completely – not just round the edges – and wet the background paper up to the masking, taking care not to leave gaps. Drop in your chosen colours. The three washes I used (viridian and Winsor blue; cadmium yellow and indigo, and Winsor blue) have blended in places to create other colours. The blues are used for the background flowers. Let this wet-in-wet stage dry completely before going on.

When your first wash is dry, draw some additional flowers and leaves in the background with a 2B or 3B pencil. Then, with the same colours as for the first washes, paint wet-on-dry behind these additional flowers and leaves – a technique also known as cutting out. Though the paper behind these shapes is dry, you should keep a wet edge to the paint so you do not leave hard lines: load the brush so the paint leaves it easily and you do not have to spread it on. When an area is evenly damp, you can also drop in other colours, just as you do with a first wash.

TIP
Use a flower mister or a well-rinsed empty plastic spray bottle to damp the paper. You can also do this using a sponge.

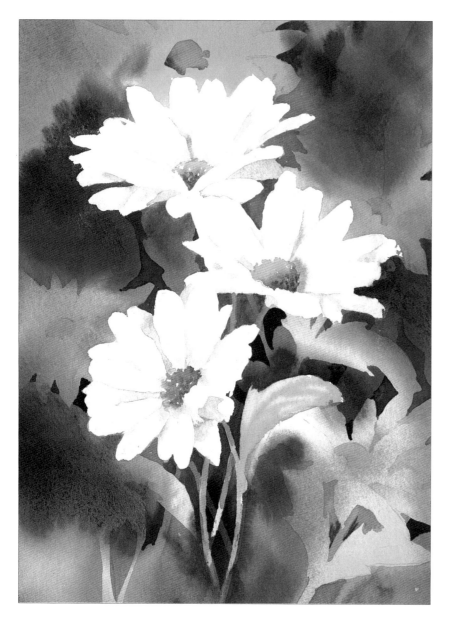

My outline sketch

Daisies

Size: 28 x 38cm (11 x 15in)
The centres of the background flowers are merely an indication, with little detail. The background was allowed to dry, then the masking was removed from the three focal flowers and the petals shaded with cobalt blue. The centres were painted using lemon yellow, then while the paint was still wet cadmium red was touched in on the side away from the light so it softened into the yellow. A touch of blue was added to darken one side, and the stalks were put in using a mixture of lemon yellow and cobalt blue.

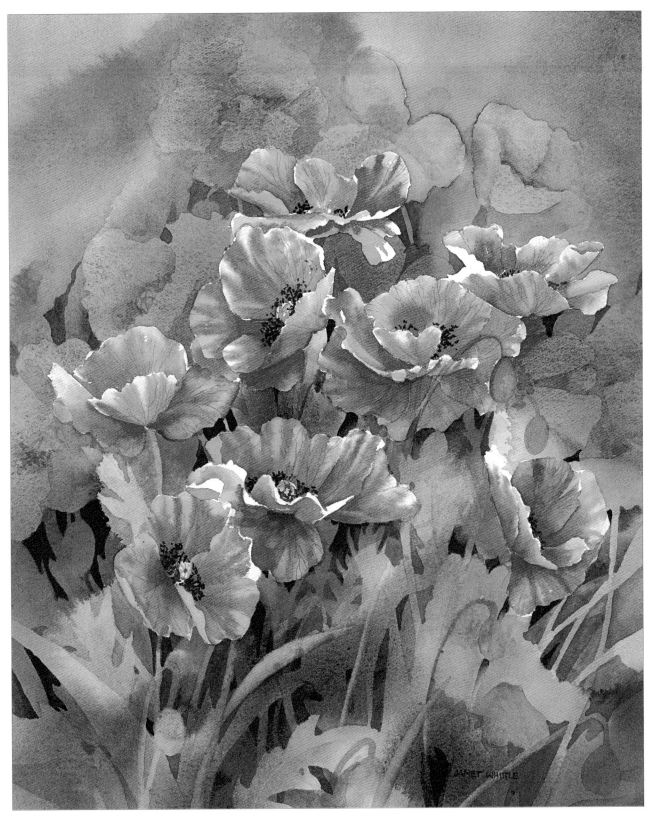

Poppies

Size: 52 x 33cm (20½ x 13in)

The red of the poppies was dropped in to the background wash and then 'cut out' with the next wash to make background flowers that fill out the composition and give another depth to the painting. Sunlight bleaches out colour and details, so on some of the edges of the focal flowers I have let the colour bleed out to the white of the paper to bring a lightness to the petals, as though the sunlight is catching them. The leaves and stalks were brought forward by painting in negative shapes, a technique I use often in my painting.

NEGATIVE PAINTING

Negative painting is a wonderful technique for picking out shapes in the background washes, and can be used for flowers or for leaves and stalks. If your background wash is quite dark you may need to reinstate your pencil guidelines before you begin. A 3B pencil is best for this as it does not dent the paper, and is more visible over a colour.

When you have done this, mix up more of the colours you have used for the background washes, and paint negative shapes behind the flowers and leaves you want to show up. Keep the effect soft and simple to ensure that the negative flowers complement rather than compete with your focal flowers. Do not add too much detail at this stage as it tends to bring things forward: you can add detail later if necessary.

Let your work dry, then plan and put in more leaf and flower shapes within the first layer of negative shapes. This gives more depth to the painting. These shapes should also be painted in negative, using a darker tone to produce a three-dimensional effect. It may sound complicated, but it will become easier with a little practice.

Clematis

The paintings below and right show two ways of approaching the same flower: you should always choose the colours and style of painting you feel happiest with. The painting on the right shows a more colourful, vibrant approach, while the one below is more ethereal and gentle.

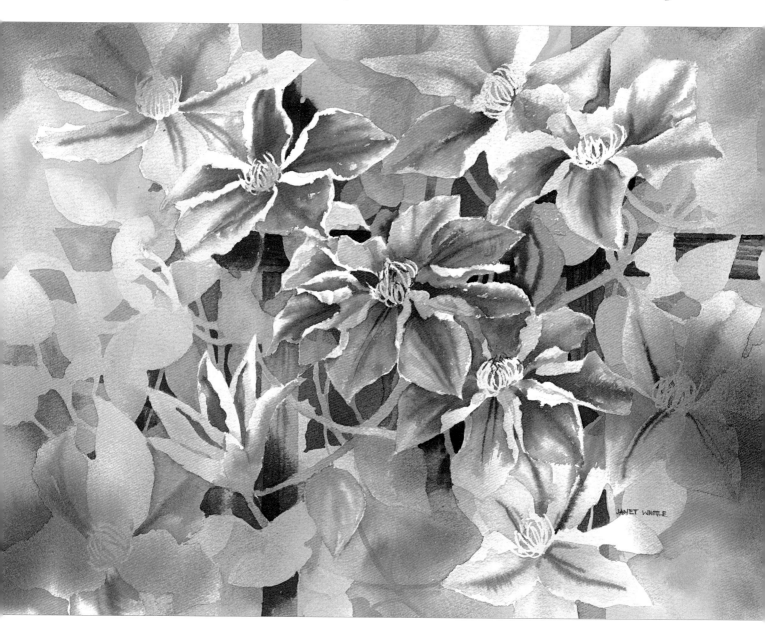

42

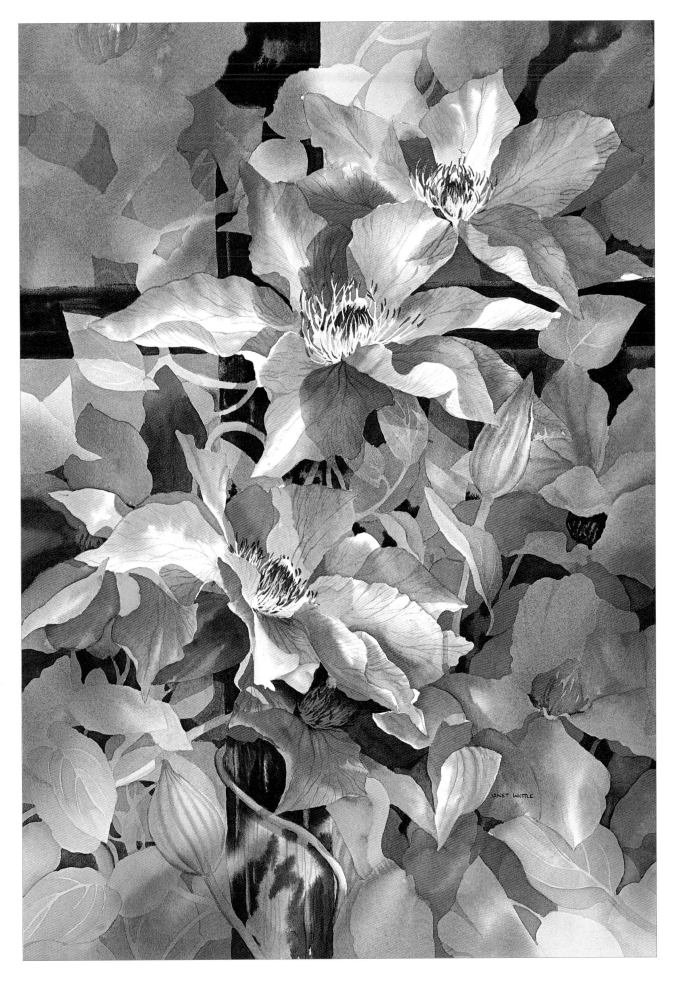

JANET WHITTLE

HARD AND SOFT EDGES

Hard and soft edges or, as they are sometimes called, lost and found, are a very important part of painting. Too many hard edges can make a composition look overworked and bitty, so it is best to vary the type of edges. At first, I like to keep most of the edges within the flowers soft, using the wet-in-wet technique. When the painting is almost finished, I assess whether any part of the image needs to be sharpened.

If you want to control a soft edge within a small shape, for example a petal, paint in the deeper-toned area first. Rinse your brush, then paint up to the edge with clear water. This makes the colour bleed forward, and creates a soft edge that is more controllable.

Softening outside edges

It is easier to remove paint from some papers than others, and you will have to discover which you prefer by trying out different papers. With most papers, however, you can soften hard edges that have been produced by masking out by dampening a small flat brush and rubbing gently across the edge. Acrylic bristles are best for this as they are a little firmer. Blot with a tissue to remove any excess moisture.

In the examples shown below, which are part of the demonstration that begins on page 52, a flat brush has been used to rub the edges of the masked areas to soften them, so they look less 'cut out'.

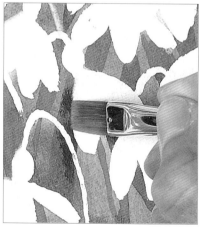

Using a flat brush dampened with clear water, gently rub the edge of the coloured area to soften it and blot with soft tissue.

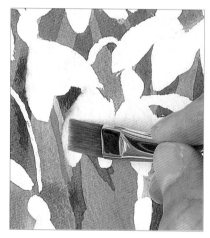

Repeat with the rest of the flowers, neatening any jagged edges.

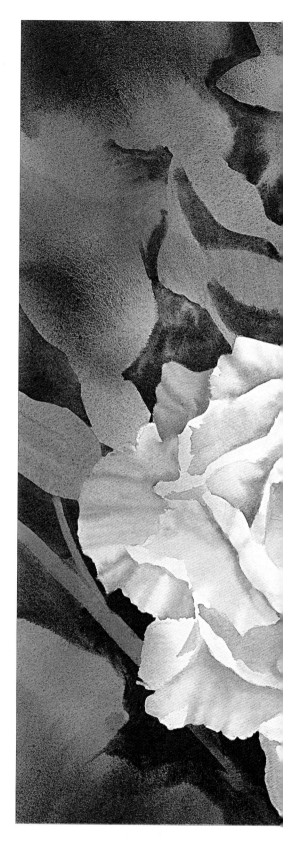

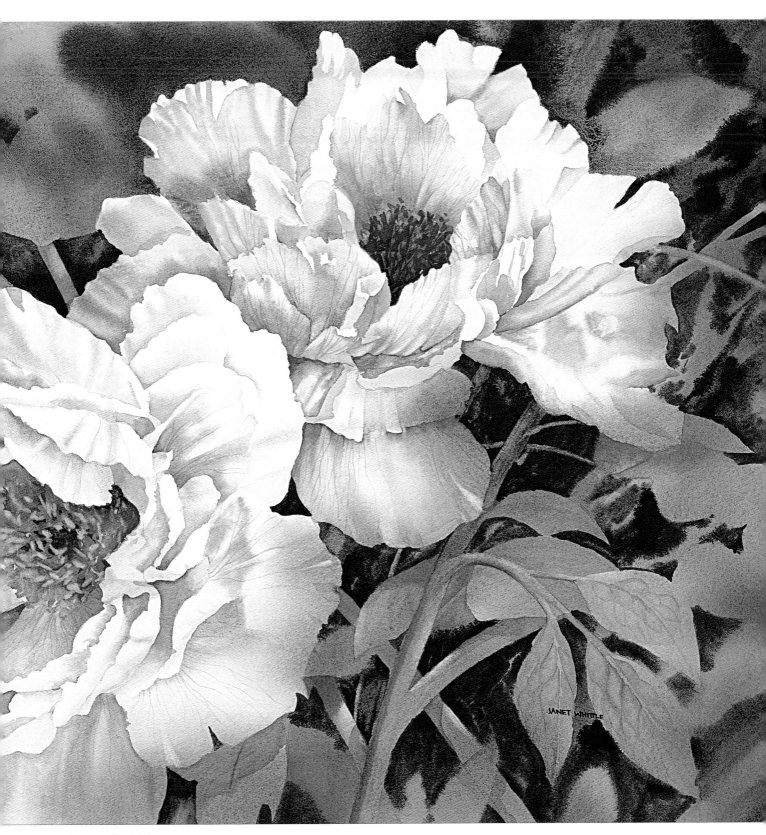

Peony *Godaishu*

Size: 55 x 38cm (21½ x 15in)

I have used hard and soft edges to paint this peony. Too much detail would make the flower form confusing to the eye. The main areas of counterchange – where the lightest lights are next to the darkest darks – have been accentuated in the middle and on the outside edges.

45

Veining

The technique you use will depend on the type of flower or leaf you are painting: some have light veining against a dark background while others are dark against light. Do not add veining to all the petals, as it can be too much. The sun will also bleach out details. It is usually sufficient to vein just a few focal petals and leaves.

For light veining against dark, you can mask out the veins over the colour of the background, then add another wash over the top. Alternatively, you can draw them in and paint the negative shapes carefully between them. Unless you want a botanical illustration, it is unnecessary to add too much detail to leaves or petals. Concentrate on the focal flowers to make them stand out more.

For dark veining against a light background, I use a small round brush (No. 00) or a small (No. 3) rigger, and paint in the vein following the contours of the leaf or petal. If there are any cast shadows, I put these in on top and darken the veining within the shadow.

Veining on pansy leaves

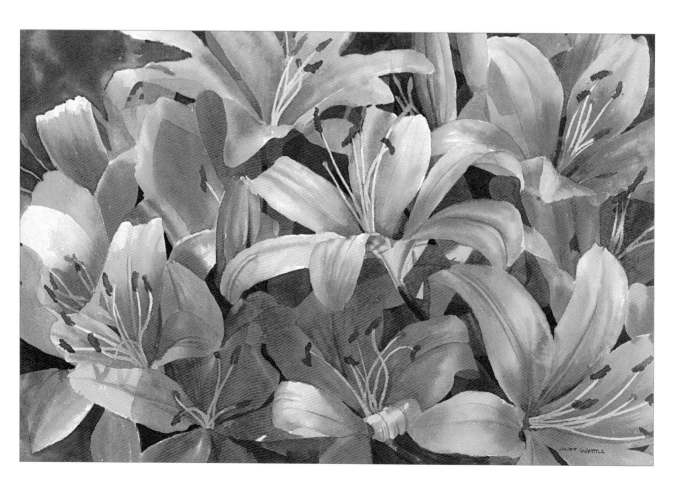

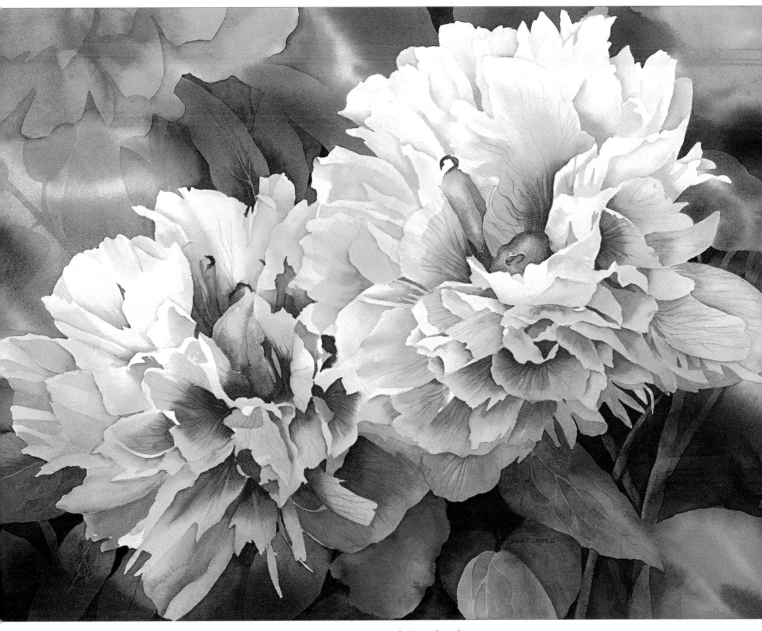

Peonies *Sarah Bernhardt*

Size: 52 x 33cm (20½ x 13in)
This is a simple treatment of an extremely intricate flower, with the sunlight catching the petals from above left. I have been sparing with the amount of veining so the effect did not become too complicated, but have deepened the veining within the shadow areas.

Opposite: Lilies *Red Night*

Size: 52 x 33cm (20½ x 13in)
This is a good example of a painting done with a limited palette (see also Cabbage White on Syringa Blossom, page 15). I masked out the stamen and used the full tonal range of white through orange to burnt orange, taking the colour to dark by adding burnt umber. These flowers are often sold in pots, making it easy for the painter to position them where the light is best. As the petals have a sheen on them, I have used the white of the paper to represent the sunlight catching them. The veining on the petals was put in using a small rigger brush.

TIP

When you are painting a larger picture, use a small rigger (No. 2 or No. 3) for veining. The hairs are longer and will hold more paint, and you will not have to reload the brush so often.

47

GLAZING

Glazing is a technique that can be used to warm up or cool down areas of a painting, and the best results are obtained with washes of transparent colour. If leaves or stalks look dull or pale, a light wash of aureolin or lemon yellow will brighten them. A cobalt blue glaze will help to accentuate focal flowers by cooling or pushing back surrounding areas. In the example below (see also page 76) the glazing gives definition and shape to the daisy petals.

The daisies look too stark because they are just white paper ...

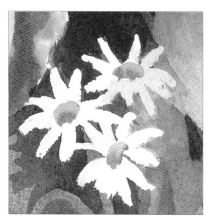

... but glazing with a pale wash of cobalt blue when the flowers are dry helps to give them definition.

Wisteria

Size: 55 x 38cm (21½ x 15in)
In this example, some of the flowers have been glazed back with a purple mix to make the focal flowers more prominent.

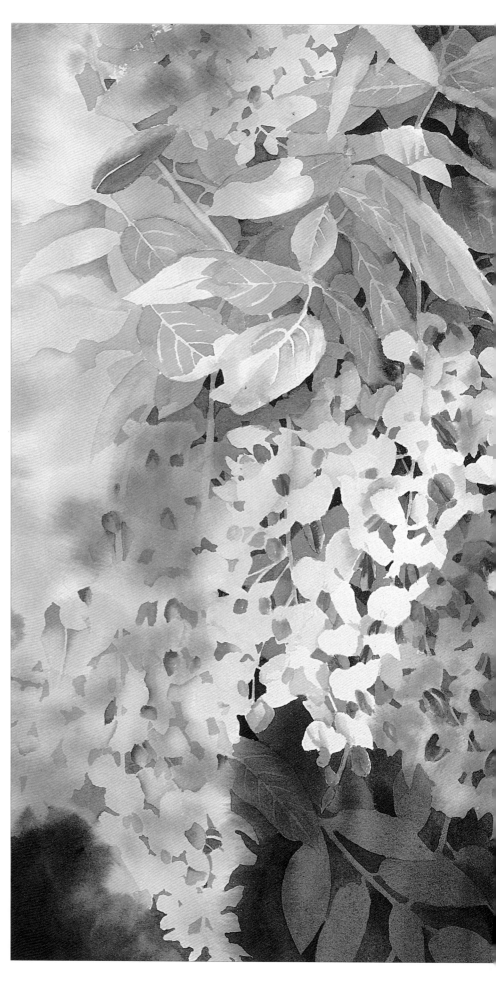

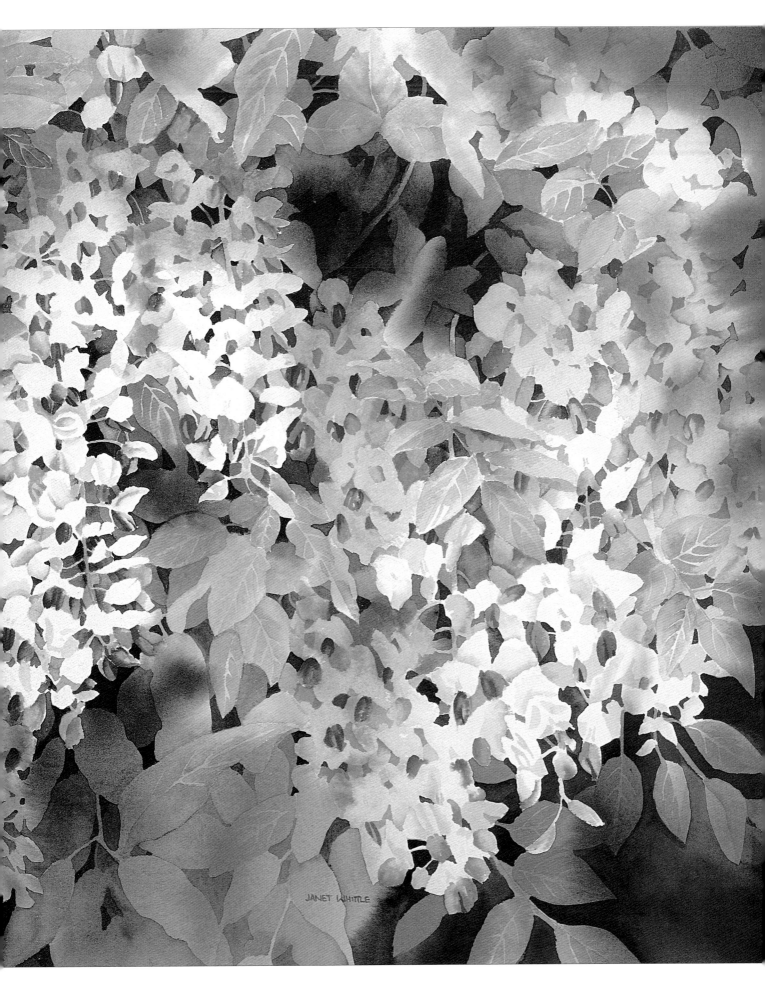

49

LIFTING OUT

Some papers allow you to lift off paint more easily than others. On certain types of paper, if you are not happy with the way your first wash has gone on, all you need to do to remove it is to rinse your work off under a tap and scrub it gently with a brush. Some types of paint leave more of a stain on the paper, so that a light blush of colour will always remain, while others can be removed completely allowing you to start again. Beginners should experiment with different paints and papers to find which ones suit different techniques.

If you want to remove definite shapes, dampen the area first with clear water (see top right), then rub the shape gently with a brush and blot it with tissue (see bottom left). For larger areas, a soft toothbrush can be used. If, when your work has dried, you find that you want to lift out more colour you can simply repeat the procedure.

You should also take care if you want to use masking fluid over colour. Because it is a rubber solution, certain types may lift off some of the colour when you try to remove it, as well as some of your pencil lines.

Dampen with clear water

Lift off colour with a tissue pad

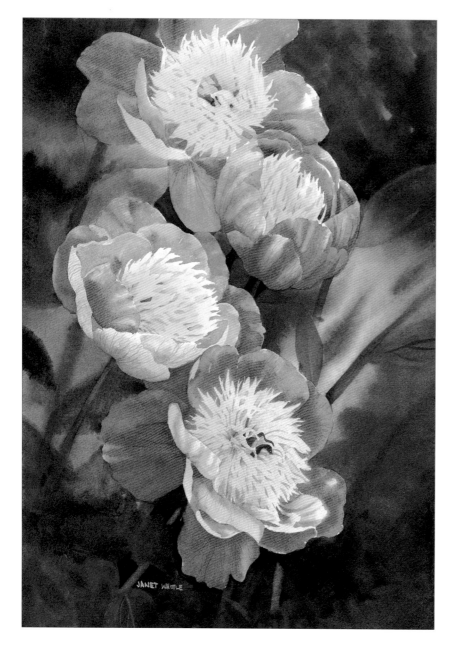

JANET WHITTLE

Stamens and stalks

Lifting out is a useful technique for putting in the stalks of flowers, as in the painting left.

In the painting of hollyhocks opposite, negative painting was used to indicate the stalks, and the stamens were masked. You can apply a first wash before masking if you like, so there is a base colour when you remove the masking fluid.

When stamens are light against dark, including hellebores (see page 24), or some types of clematis (see pages 42-43), it is easier to mask them out before you begin to paint.

When the stamens of flowers are dark against light, they can be painted in last over the colours of the flower. This technique is quite easy – see the poppy demonstration on page 77.

Peony *Bowl of Beauty*
Size: 28 x 38cm (11 x 15in)
The main stalks on these flowers were lifted out using a 13mm (½in) flat brush to give the impression that they run behind the leaves. A stalk was painted dark against light in the background.

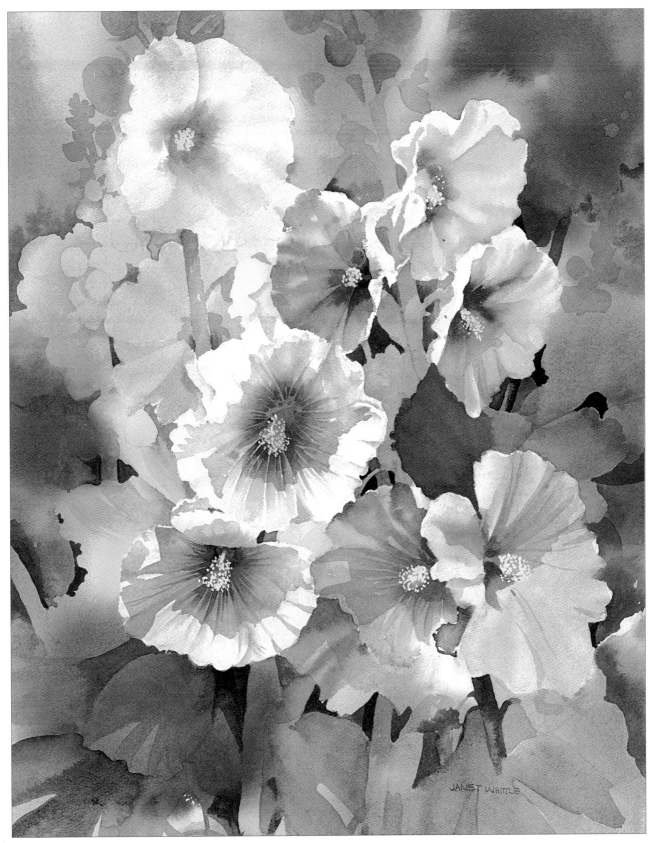

Hollyhocks

Size: 52 x 33cm (20½ x 13in)
The shadows on the flowers are cobalt blue with a touch of light red: the
darker the shadows, the more the illusion of bright sunlight is created.
Dramatic shadows can turn a painting into something special. Complete the
flowers before removing the masking fluid and paint in the stamens.

Snowdrops

These have lovely, simple shapes to practise masking-out techniques on. Because they are so small, you will need to mask out the whole flower so the first washes can be put on over them. Draw the flower heads and stems carefully before you begin painting. You can draw the leaves in at this stage too, or you can leave them until you have completed the first wash if you prefer.

This project is a good exercise for practising a background wash, and also incorporates the lifting out technique. The colours were chosen because some pigments will lift off back to white, while others are more staining and leave some colour on the paper. It was carried out on watercolour board, which you can buy in most good art shops. This allows the paint to lift off more easily.

Make sure you choose your paper according to the techniques you are hoping to use. A surface which lifts off as easily as watercolour board is not suitable if you want to do a lot of negative painting: when one colour is applied over another – unless it is done extremely gently – it will lift off the colour underneath and make it muddy. The negative shapes in this composition are small, so this characteristic should not cause too much trouble. The light in this composition is coming from the left, so the shadows and highlights are put in accordingly.

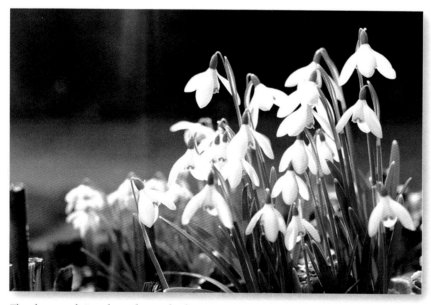

The photograph I used as reference for this composition

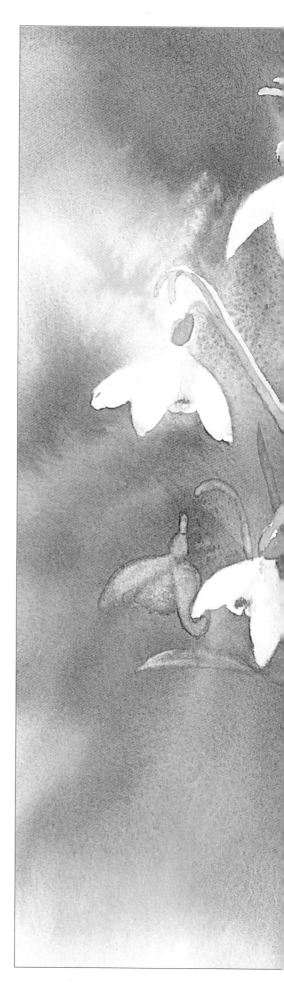

The finished painting
Size: 55 x 38cm (21½ x 15in)
I have used my imagination for the background colours, choosing tones that complement the delicacy of the flowers.

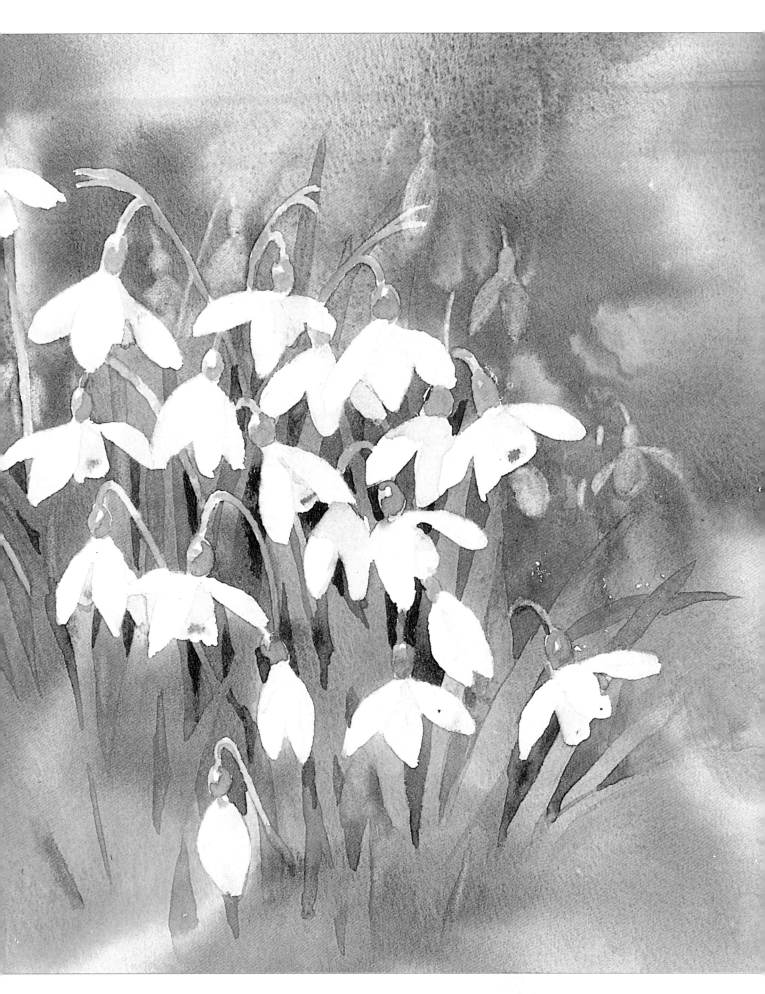

Before you begin to paint, mix the main washes you will need:

1) Cobalt blue
2) Winsor blue and viridian
3) Winsor blue and burnt umber
4) Viridian and burnt umber
5) Cadmium yellow and sap green

YOU WILL NEED

Watercolour board
Brushes Nos. 8 and No. 00
Flat brush: 13mm (½in)
Masking fluid and old brush
Palette for mixing
Watercolour paints: I used
cobalt blue; Winsor blue;
viridian; cadmium yellow; sap
green and burnt umber.
Plastic eraser

My outline sketch, with the masking fluid tinted blue for clarity

1 Draw an outline sketch and apply masking fluid to the main flower heads and stems. Mix the main colours you want to use. Wash over the paper with water until the surface is shiny, then repeat the process so the water sinks in more. Add the Winsor blue and viridian wash using a No. 8 brush.

2 When putting in backgrounds I generally work from light to dark. Add the cadmium yellow and sap green wash...

3 ...and the cobalt blue, working very quickly.

TIP

If your paper begins to dry too much, you can damp it down with plain water from a spray mister rather than touching the paint.

4 Finish adding the washes so that they cover the paper, remembering that they will spread when you tip the board

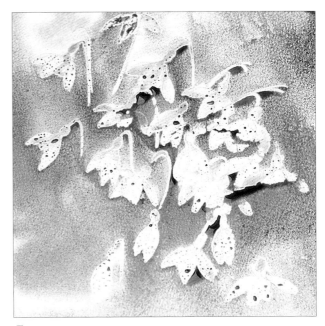

5 ... and tip the picture so the colours merge.

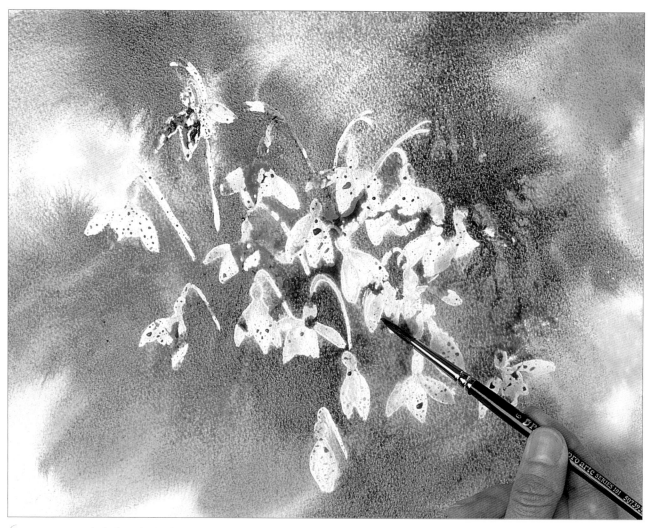

6 Put in some darks beside the flowers to make them stand out, remembering that everything will diffuse on the wet paper, and will also dry lighter.

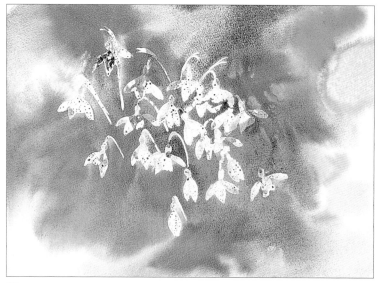

7 Leave your work to dry thoroughly, or wait until the shine has gone off and use a hair dryer to speed up the process.

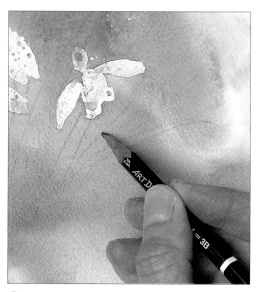

8 Reinstate the lines with a 3B pencil, using the initial sketch for guidance if necessary.

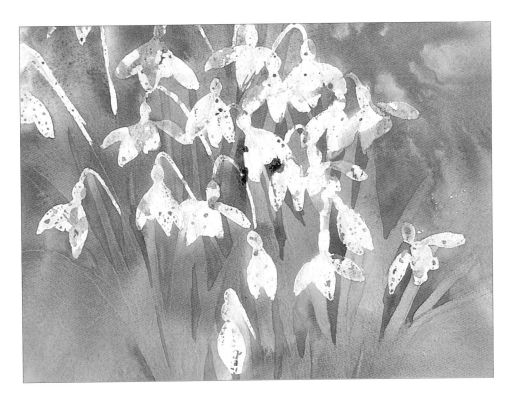

9 Using a mix of viridian and burnt umber, paint in negative shapes behind the flowers and leaves.

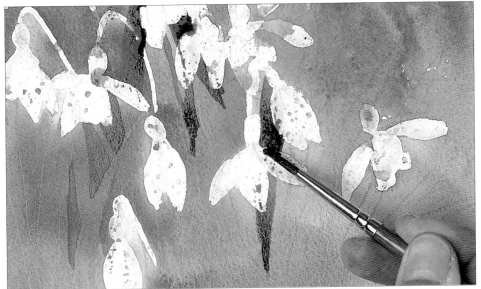

10 Using a deeper mix of viridian and burnt umber, darken some areas to show up the main flowers and give the painting more depth.

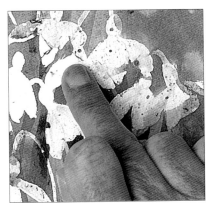

11 Leave your work to dry thoroughly then rub off the masking fluid with your fingertips.

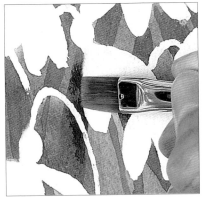

12 With a flat brush and plain water, gently rub the edges of the coloured areas to soften them.

13 Repeat with the rest of the flowers, neatening any jagged edges.

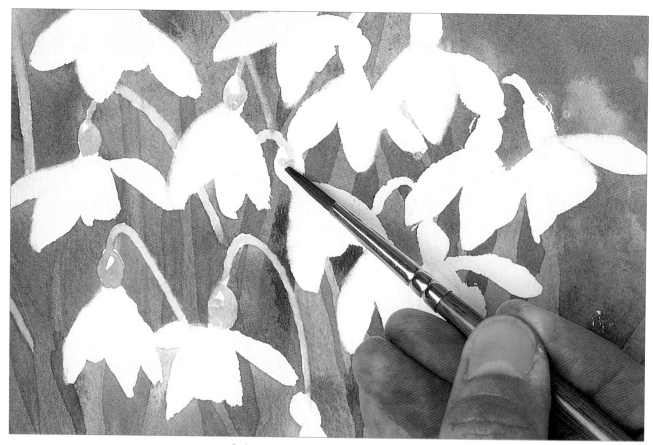

14 Using the No. 8 brush, mix viridian and cadmium yellow and paint in the tops of the flowers and the stalks, adjusting the intensity of the wash throughout to vary the tones. Remembering where the light is coming from, reserve highlights throughout the painting.

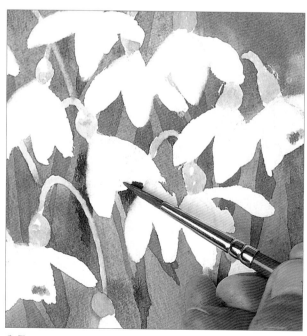

15 Put in detail on the inner petals using lemon yellow, adding a dab of viridian wet-in-wet on top.

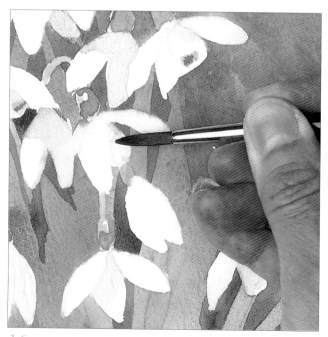

16 Using a pale mix of cobalt blue, shade in the petals away from the light and then the petals inside the flowers.

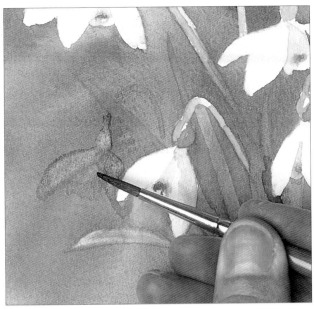

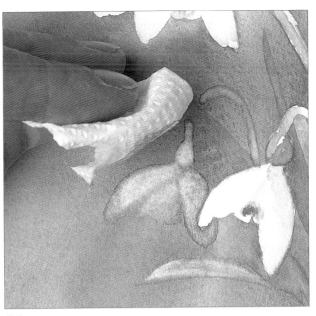

17 With plain water and the point of a fine (No. 00) brush, dampen an area of the background in the shape of a snowdrop.

18 Blot with a pad of absorbent paper to lift out the shape of the flower.

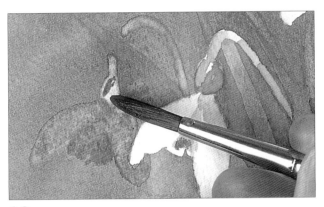

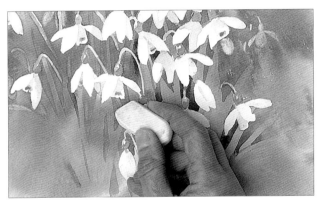

19 Knock the starkness of the lifted-out flower back with a pale wash of cobalt blue. Put in the green top of the flower.

20 Leave the picture to dry thoroughly then remove the pencil lines with a plastic eraser.

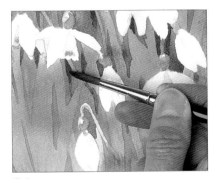

21 Work over the whole painting as necessary, redefining, adding more negative painting in a dark mix of viridian and burnt umber, and generally sharpening up the detail.

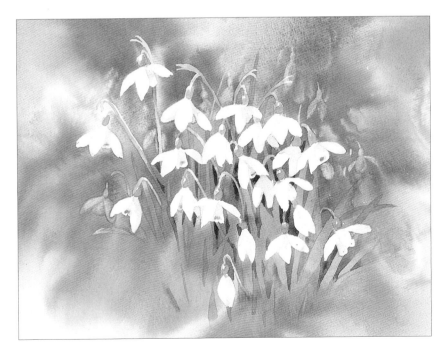

The finished painting

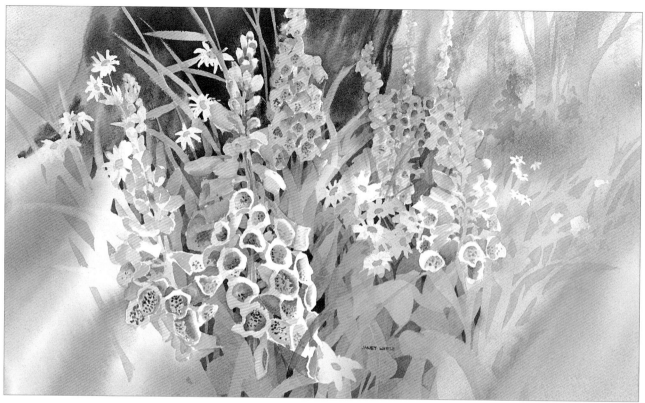

Above: Foxgloves

Size: 55 x 38cm (21½ x 15in)
For this letterbox-format composition, I added the background trees to create the impression of the woodland or hedgerows where these flowers often grow, and to show up the main flowers.

Below: Irises

Size: 61 x 74cm (24 x 29in)
I like to vary the style of presentation, and the stalks of these flowers are so long that a letterbox format seemed to suit it. I also like to vary the colours within a composition.

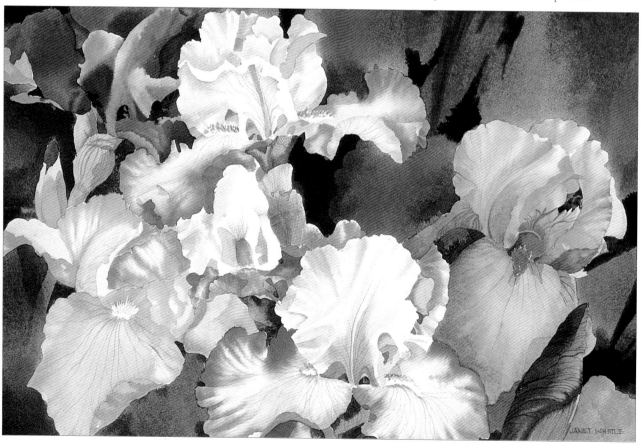

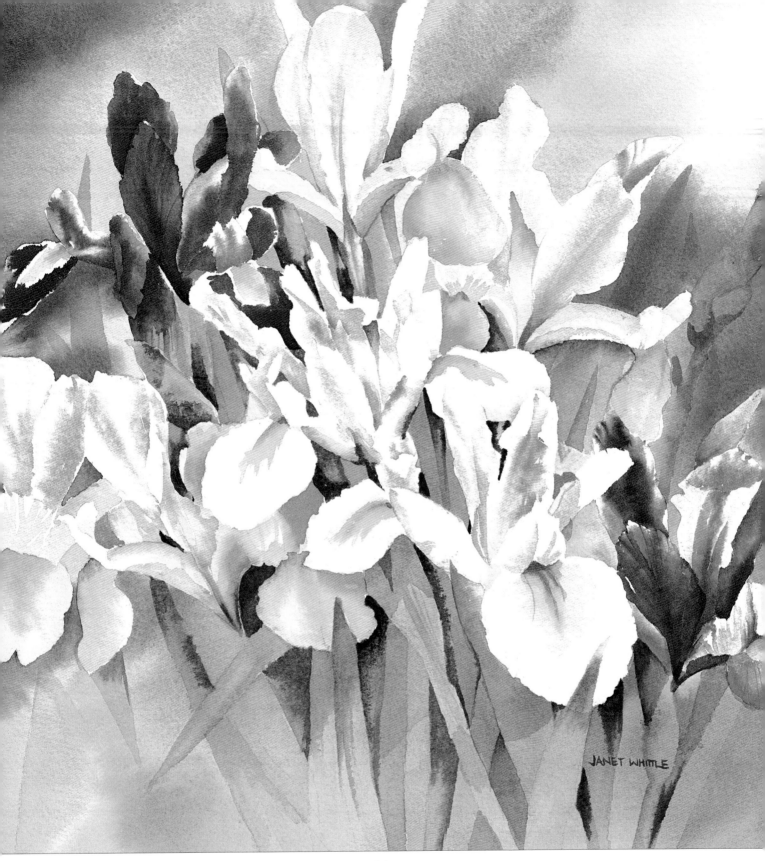

Irises

Size: 38 x 38cm (15 x 15in)
These flowers were very bright and fresh, so I
preserved areas of white to create this effect, putting
the whites next to the blues and yellows to keep the
whole composition vibrant and alive.

Himalayan Poppy

Watercolour has a reputation for being wishy-washy, but used properly it can be as bright and colourful as any other medium, as this demonstration shows. I have many photographs of this flower as it is one of my favourites, and I used a selection to develop the composition. The negative painting in the background is fairly basic. The petals of the poppies were put in wet-in-wet and the stamens were masked out with dots. I interlocked some of the stamens as, depending on the angle of the flower, they appear more dense in some areas than in others .

The more extremes of tone you can create in a painting, the more vibrant it will be. The green and the blue I used are very similar in tone. This could result in a bland painting, so I compensated by exaggerating the tonal values. I accentuated the brightness of the petals by leaving the white of the paper in places, and towards the centre of the flowers, I deepened the intensity of colour to show up the stamens, making the flowers appear lighter. I placed some of the darks in the background next to the lighter areas of the petals to create depth.

My source photographs

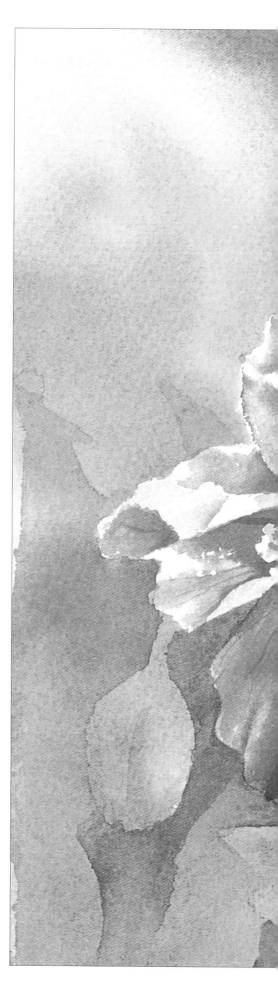

The finished painting

These lovely flowers, Meconopsis Betonicifolia, are among my favourites and I paint them often. I have tried to grow them several times, but they are not happy with the soil in the area where I live. I take reference photographs whenever I get the chance.

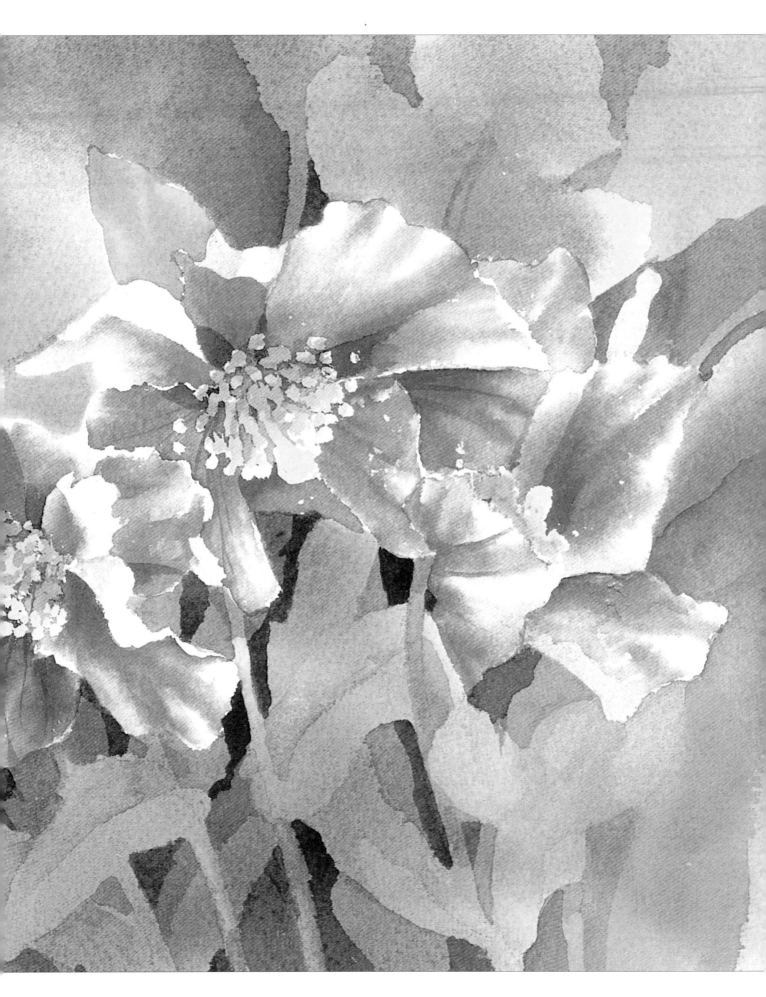

Before you begin to paint, mix the main colours you will need:

1) Viridian and Winsor blue
2) Cobalt blue
3) Cobalt blue and viridian
4) Burnt umber and viridian
5) Permanent rose
6) Sap green and cadmium yellow

YOU WILL NEED

Watercolour paper 300lb (640gsm)
Drawing board and pins
Masking fluid and old brush
Round brush No. 6
Rigger No. 3
Watercolour paint: I used Winsor blue; cobalt blue; cadmium yellow; burnt umber; permanent rose; sap green; viridian and alizarin crimson

The outline sketch, with masking fluid added to outline the main flowers

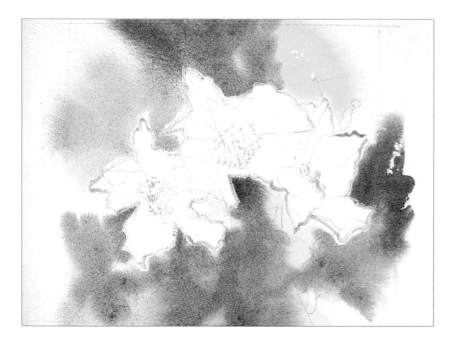

1 Pin or stretch your watercolour paper to the drawing board. Mix up the main colours you want to use. Wet the paper up to the masking fluid outline. Using the No. 6 round brush, put in the background colours. Working from light to dark, begin with the yellow mix of sap green and cadmium yellow and follow with the green mix of cobalt blue and viridian and the plain cobalt blue. Let the colours spread right up to the edge of the masking fluid.

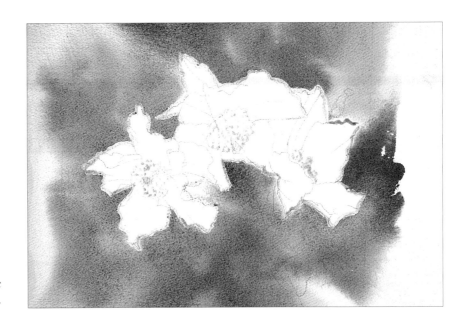

2 Tip the paper to merge the washes. Leave your work to dry.

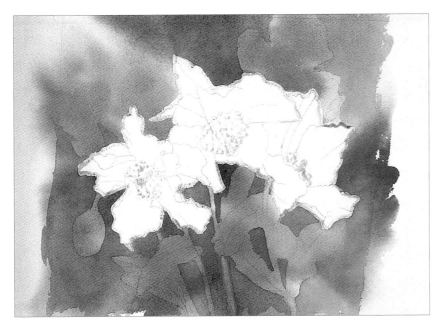

3 Begin to put in the negative painting using the wash of viridian and Winsor blue and following the pencil lines. Let your work dry.

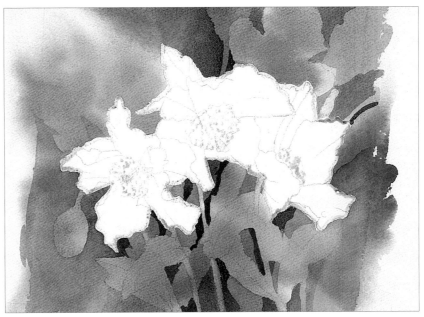

4 Change to the mix of burnt umber and viridian and put in more negative painting, cutting out again within the first negative shape you painted.

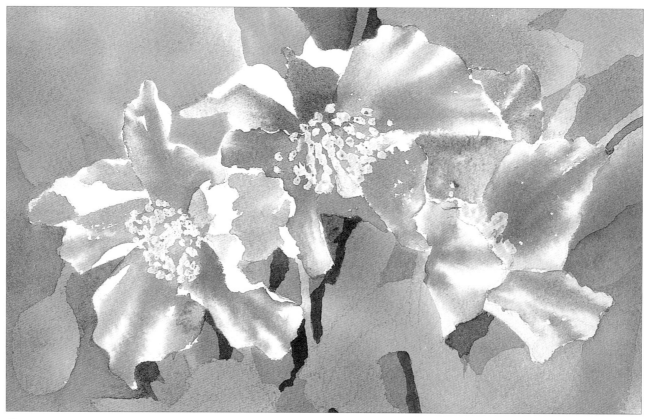

5 Rub the masking fluid off the petals, but leave it on the centres. Wet the petals using a No. 6 brush, and put in the cobalt blue wash, followed by a touch of alizarin crimson.

6 Still working wet-in-wet, paint in the rest of the flower petals, dampening each petal and running in the colour, following the tonal values as closely as possible, leaving some hard-edged white areas of dry paper.

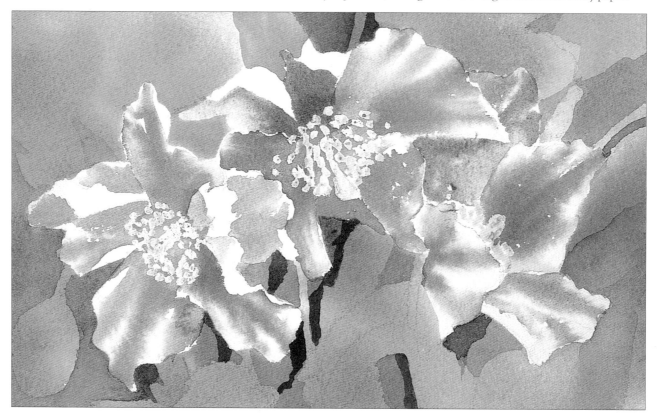

7 Deepen the blue on the petals using a mix of Winsor blue with a touch of cobalt blue. Work wet-on-dry and soften the edges with a little water.

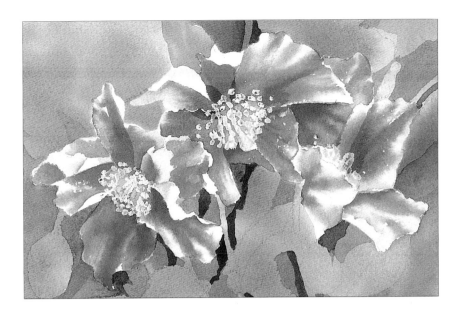

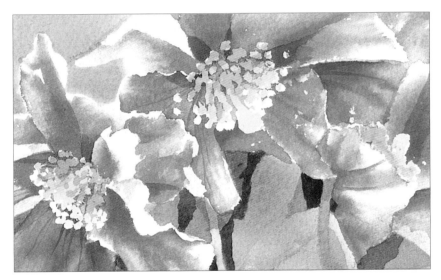

8 When your work is dry, remove the masking fluid and paint the stamens in lemon yellow, leaving some white flecks. Deepen the tone with cadmium yellow in the direction away from the light and where the petals would cast a shadow on the stamens. Produce the effect of veining on one or two leaves by putting a slightly deeper wash between the veins so they are light against dark.

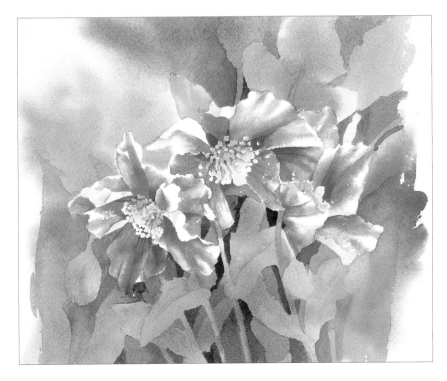

The finished painting, before cropping

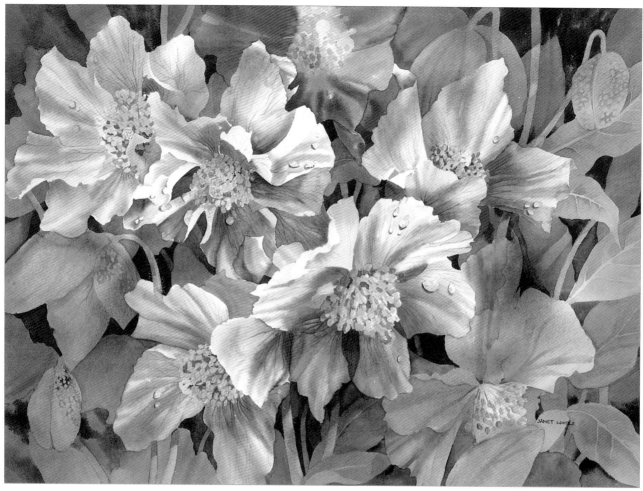

Himalayan Poppy *Meconopsis betonicifolia*

Size: 55 x 38cm (21½ x 15in)

A different study of one of my favourite flowers. I worked this painting from photographs taken at Hampton Court Palace, London. It was just after a shower of rain, and they looked absolutely stunning. The delicate blue of the petals with the light shining on them were all the inspiration I needed to paint.

Tree Poppy *White Cloud*

Size: 55 x 38cm (21½ x 15in)
Before masking out the shapes of the main flowers, I put in pale washes of yellows, pinks and blues to take a little of the stark whiteness off the flowers. Negative shapes have been painted in the background wash to cut out the flower shapes.

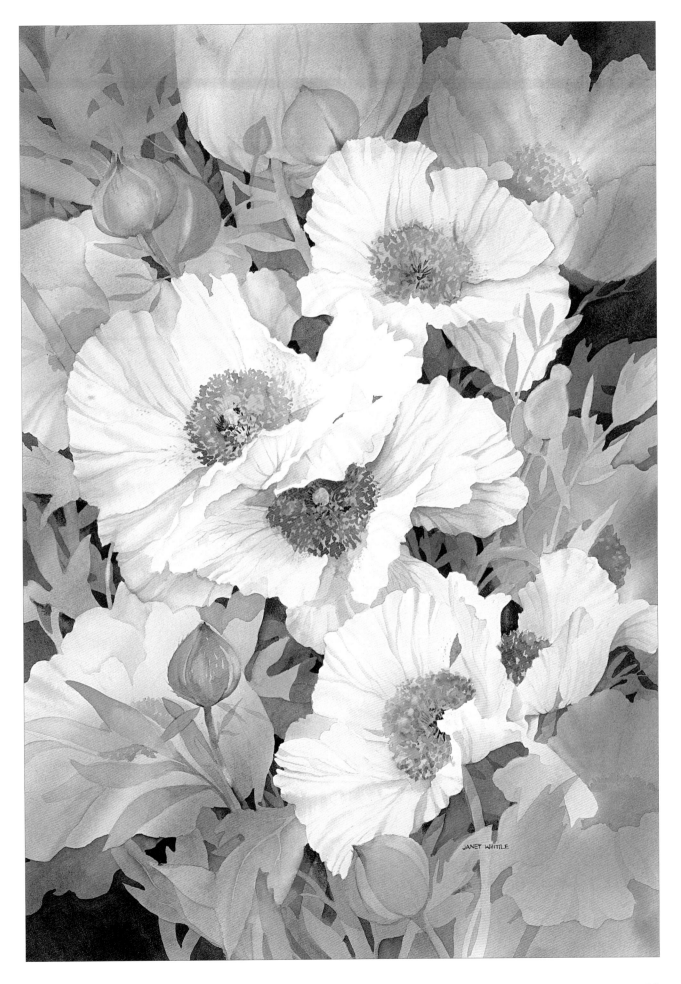

JANET WHITTLE

Poppies and Daisies

This demonstration shows how flowers of very different sizes can be used to complement the focal flowers. The petals of the poppies are painted first in cadmium yellow and, while they are still damp, the red is painted in. The yellow glows through the red, giving a luminous effect. I used the best aspects of several photographs to produce the final composition.

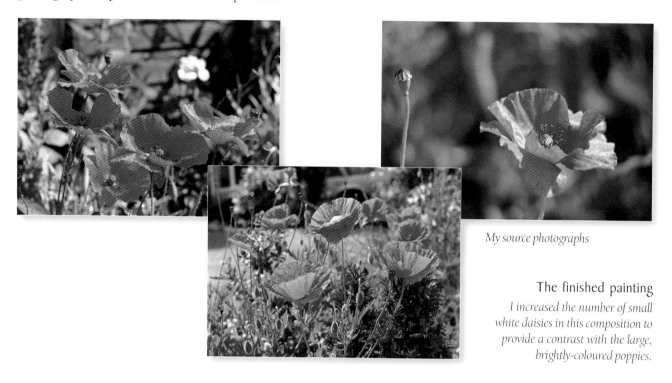

My source photographs

The finished painting
I increased the number of small white daisies in this composition to provide a contrast with the large, brightly-coloured poppies.

The outline sketch I used

Sketch with masking fluid to outline the main flowers

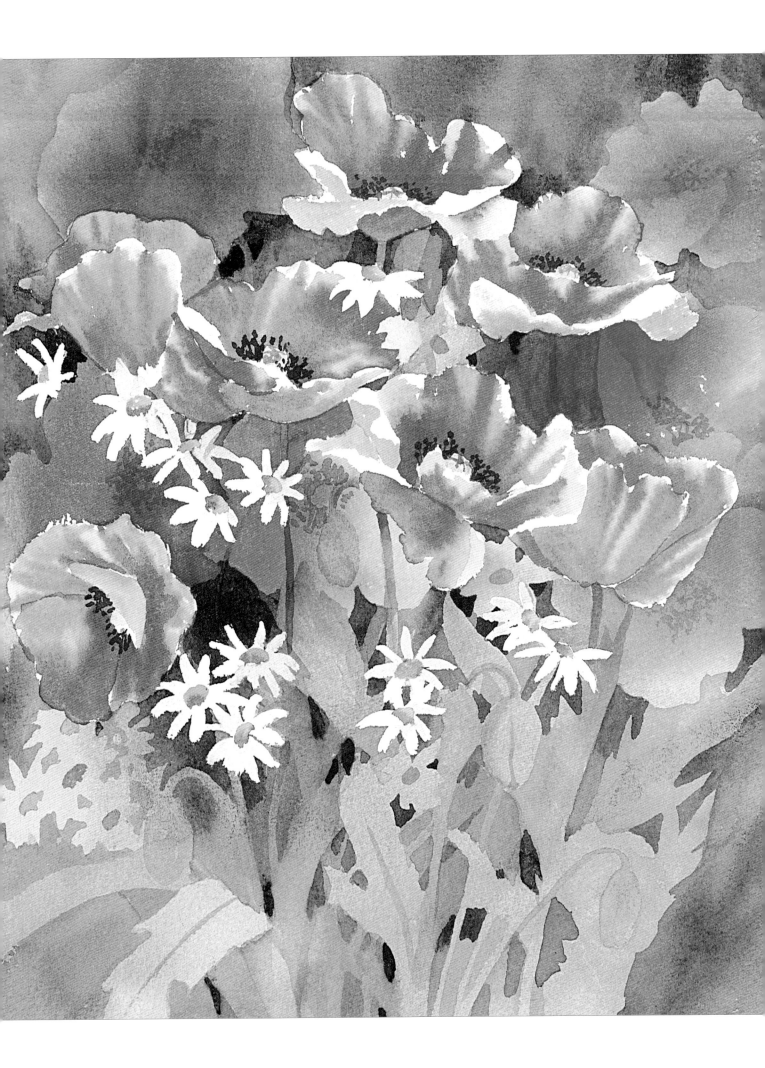

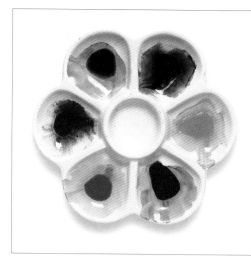

Before you begin to paint, mix the main colours you will need:

1) Burnt umber and viridian
2) Cadmium yellow
3) Translucent orange and cadmium red
4) Lemon yellow and viridian.
5) Cobalt blue
6) Viridian and Winsor blue

YOU WILL NEED

Watercolour paper 640gsm (300lb)
Drawing board and pins
Pencils: HB and 3B
Masking fluid and old brush
Round brushes: No. 6 and No. 8
Large soft brush
Watercolour paints: I used cadmium yellow; lemon yellow; cobalt blue; viridian; Winsor blue; translucent orange; cadmium red and burnt umber.

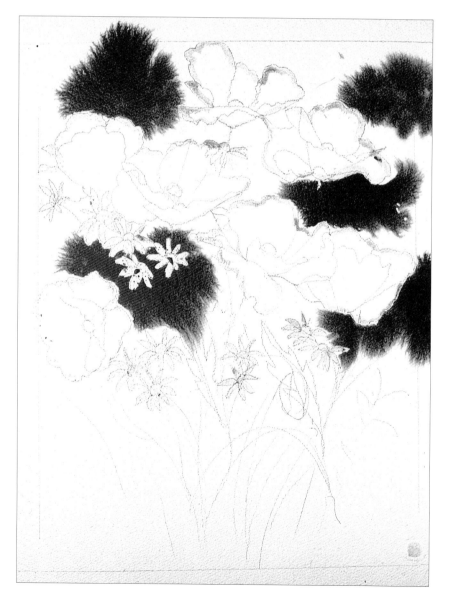

1 When the masking fluid has dried on the outline sketch (see page 70), use a large round brush, No. 8 or larger, to wet the paper up to the masking lines, leaving the flower shapes dry. Load your brush with the mix of translucent orange and cadmium red and drop it in behind the flower shapes, making sure the colour runs up to some of the masking lines.

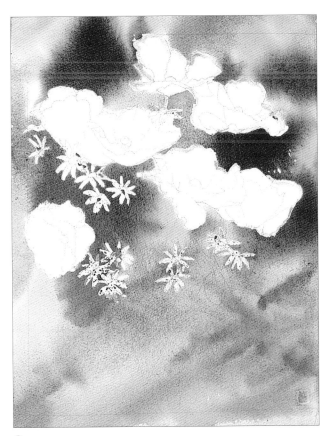

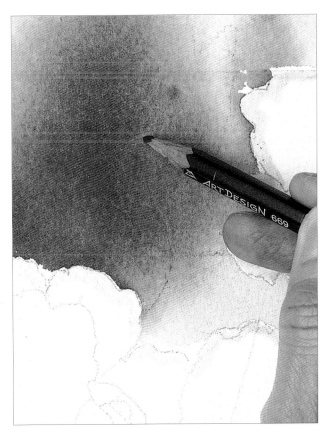

2 Continue dropping in background colours, working from light to dark, while the paper is still wet. Begin with cadmium yellow, followed by cobalt blue, the bright green mix and the red mix. Tip the paper to blend the colours slightly. Leave to dry.

3 If you are not happy with the effect, dampen the painting using a brush and drop in more colours. Pick up any excess droplets with a damp brush and leave to dry flat. Draw in the poppies in the background and any additional leaves and stalks you want to include, using a 3B pencil.

4 Paint in the negative shapes behind the background poppies, leaves and stalks using more concentrated mixes of the colours used in the first washes – not too dark, but so that you can see the shapes of the composition.

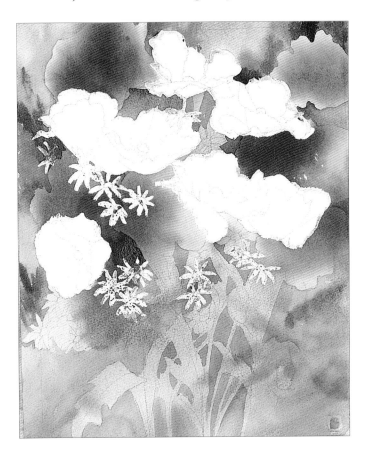

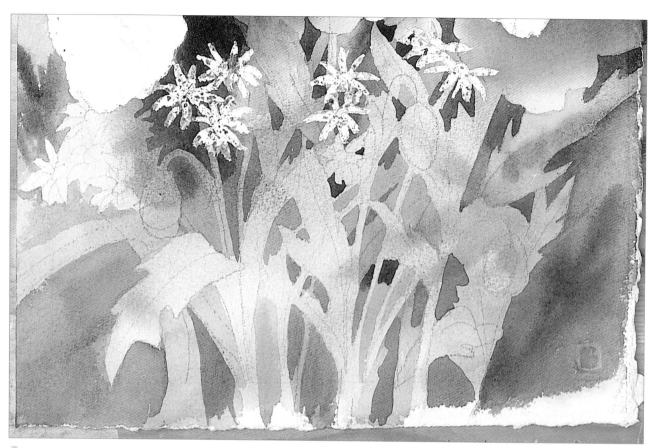

5 Add some darker negative shapes within the negative shapes you have painted to give the background more depth. Leave your work to dry.

6 Remove the masking fluid by rubbing it gently with your fingertips, then brush away the residue with a large soft brush.

7 Dampen the foreground petals with the No. 8 brush. Painting one petal at a time, put in the cadmium yellow wash then quickly add the translucent orange and cadmium red wash so that it merges as shown.

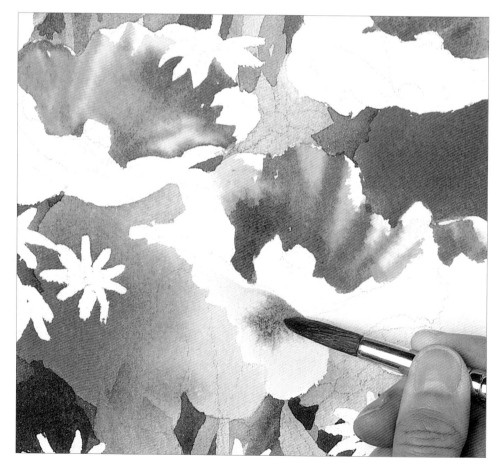

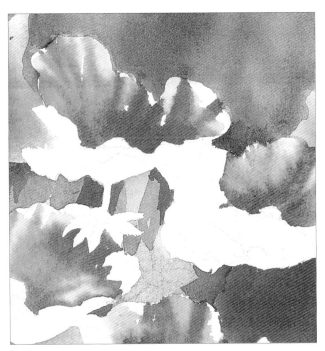

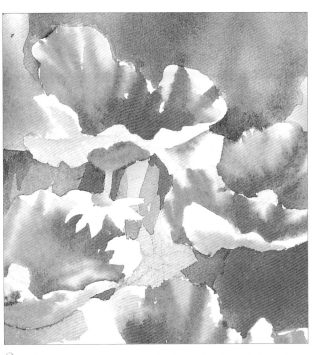

8 To achieve the right effect, paint in the back petals first so they go from dark at the centre to light at the edge ...

9 ...then paint in the petals at the front, leaving a light, soft edge at the top.

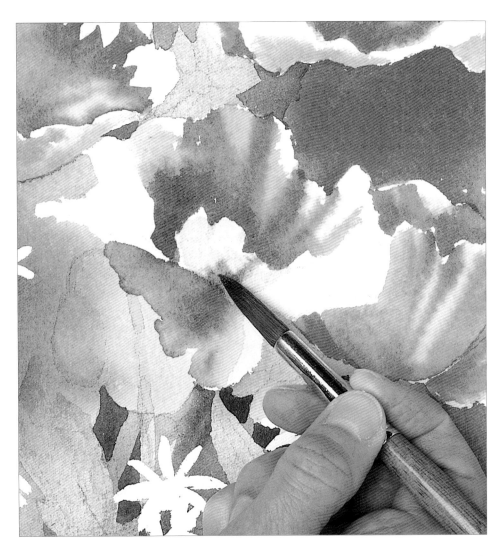

10 Complete all the poppies, following the tonal values as closely as possible, as shown here.

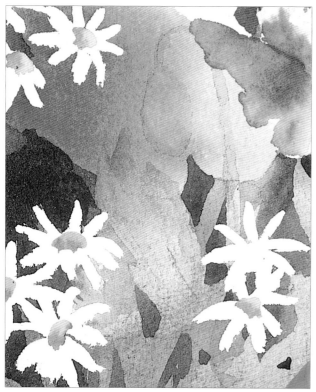

11 Put in the centres of the daisies, using a wash of cadmium yellow first, then drop in some of the cadmium red and orange wash on the side away from the light.

12 Put in the stamens of the poppies using a dark mix of Winsor blue and burnt umber.

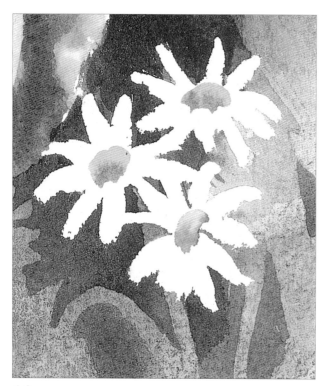

13 The daisies look too stark because with the masking fluid removed they are just white paper...

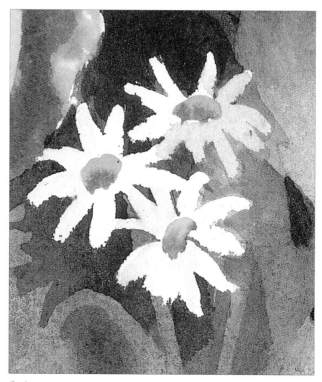

14 ...so add glazing with a pale wash of cobalt blue to some of them to make them recede into the background slightly and give them some form.

15 Work over the areas of negative painting, sharpening up detail if necessary and adding veins to some of the leaves.

16 Knock back some of the poppies in the background using a pale wash of cobalt blue.

17 Put in the stalks of the poppies that are dark against light using cadmium yellow with a touch of viridian and a No. 6 brush. When dry, remove the pencil lines.

The finished painting

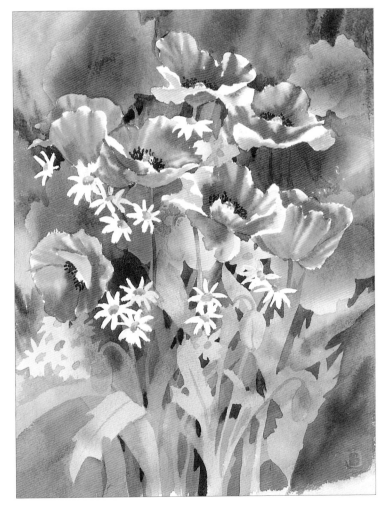

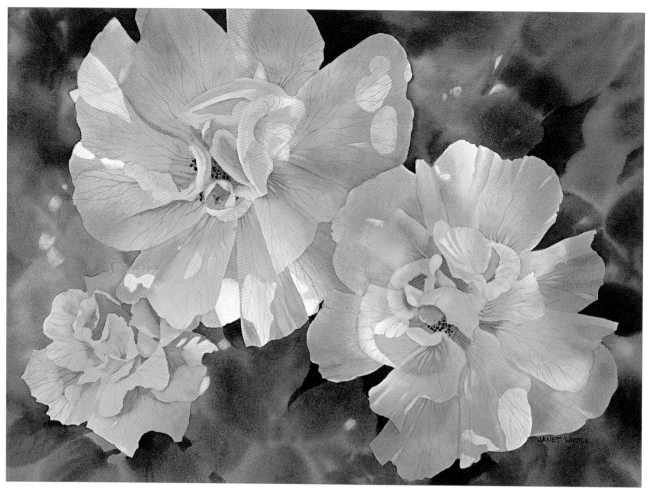

Rose *Buff Beauty*

Size: 55 x 38cm (21½ x 15in)

For this painting, a series of light blushes of colour were put over the paper and allowed to dry, then the flowers were masked on top of the washes. The sunlit areas were also masked to preserve them from the later washes. I mixed different tones of blue and put in the lighter tones first, then dropped in the darker areas wet-in-wet. I painted the flowers with yellows, pinks and orange mixes, then removed the masking and softened the edges. As these areas were now white and a little harsh, I toned some of them down with glazes to push them back.

Irises After the Rain

Size: 55 x 38cm (21½ x 15in)

This painting shows how effectively dewdrops can be used in a composition to capture the lovely effects of sunshine after rain. I think it is pure magic, which was why I was inspired to paint these irises. Capturing the moment, and effects which have the power to move you, is what painting is all about. The background was painted wet-in-wet. I dropped in the colours including the purple I wanted to use on the flowers, so that I could cut out some of the background flowers when it was dry to fill out the composition. The petals were painted wet-in-wet. I dampened the petal area first, then dropped in the yellow so it softened off, then, working from the outside edge I dropped in the purple mix so it too would soften forward, leaving a paler area in the centre of the petal. Timing is all with this technique: if your paper is too wet the colours will bleed too far, and if it is too dry they will not bleed far enough. Practice is essential, but if you find doing the whole thing too daunting, do one colour at a time, wait for it to dry, then wet it again and drop in the other colour.

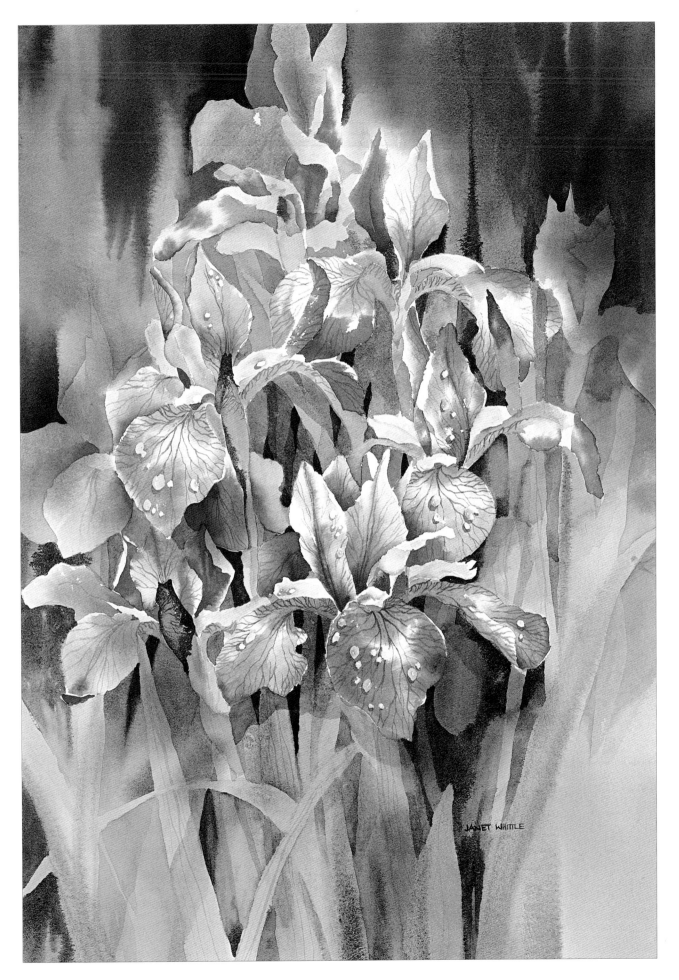

JANET WHITTLE

Scabious

I have painted the background for this demonstration almost entirely wet-in-wet. This is because scabious leaves are very small and grow mainly at soil level, so I wanted the background to suggest other foliage to add interest and colour to the painting. The centres of these flowers look different when they are newly opened, which makes an interesting feature on some of the blooms.

More interest is added by the way the shades of the flowers vary from white to lavender. Remember if you have good reference material for the flower form you can paint it in different colours as long as they are true to the type of flower. This will add variety to your composition. I have interlocked some of the focal flowers rather than placing them separately like a flower arrangement. I feel this is important because these flowers also grow in the wild and I like to give the impression that they are growing in woodland or hedgerow.

Perspective is also important when you are painting flowers like these. If the flowers tip towards you or away from you, make sure the shape of the centres changes from circular to oval, and that the petals are lengthened or foreshortened accordingly.

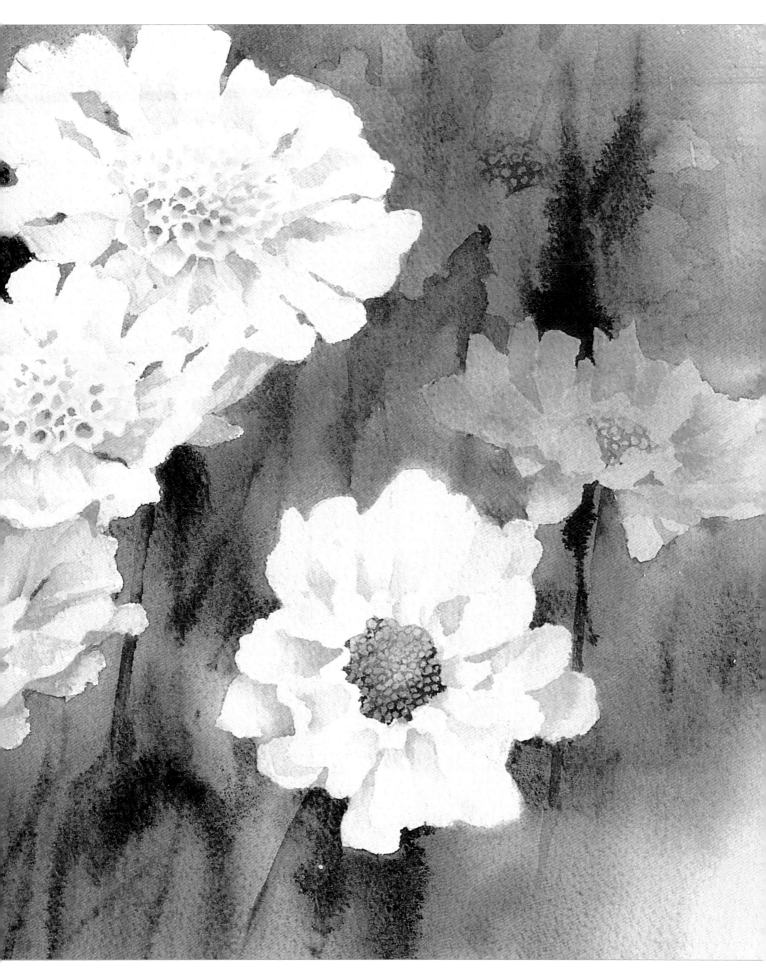

Before you begin to paint, mix up the main washes:

1. Indigo and Winsor blue
2. Cobalt blue
3. Viridian and Winsor blue
4. Cobalt blue and lemon yellow
5. Permanent rose and Winsor blue
6. Sap green and lemon yellow

You WILL NEED

Watercolour paper
Round brush No. 6
Rigger No. 3
3B pencil
Drawing board and pins
Masking fluid and old brush
Watercolour paints: I used cobalt blue; Winsor blue; indigo; viridian; lemon yellow; cadmium yellow and sap green

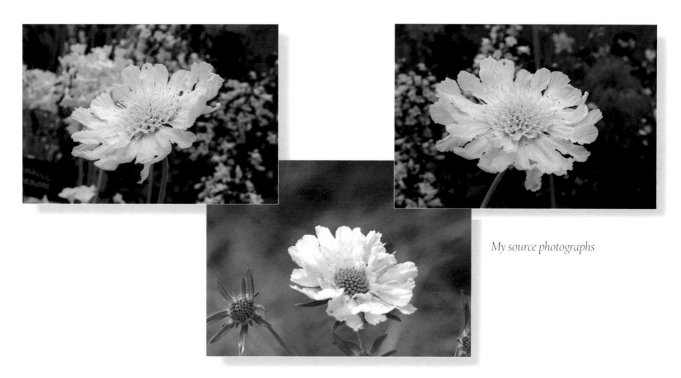

My source photographs

My outline sketch

1 Mask the focal flowers and allow the masking fluid to dry. Using a No. 6 brush, wet the background right up to the masking fluid, and put in the background colours starting with the lightest and working through to the darkest. Tip the board (see page 28) and let the washes blend.

2 Leave these first washes to dry, remembering that they will dry quite a lot lighter. Draw in the background flowers using a 3B pencil.

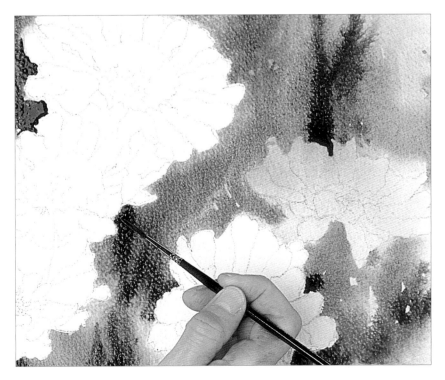

3 Dampen the paper with plain water. Put in a wash of sap green and lemon yellow using a No. 6 brush, working round the background flowers, then change to a No. 3 rigger and indicate the darker stalks and leaves using a dark mix of indigo and Winsor blue. The shapes can be left abstract, as only an indication rather than detail is required.

4 Let your work dry flat.

5 Put the first colour on the focal flowers using a pale wash of lemon yellow. Paint the centres of the two flowers at the bottom, then drop in some of the sap green mix so that it blends and varies the tone from light to dark.

6 Using the mix of permanent rose and Winsor blue, deepen some of the shadows on the flower heads to give them more depth. Using the dark green mix and the small rigger, paint in between some of the petals next to the centres to indicate separation.

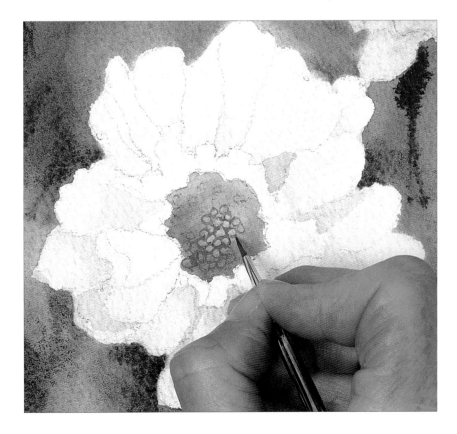

7 Still with the small rigger brush, and with a darker mix of green paint, add detail to the centre of the nearest flower by painting in tiny circles.

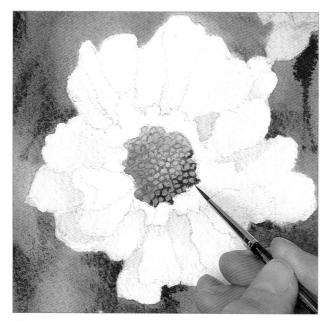

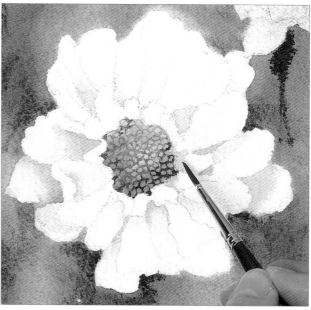

8 Darken the circles away from the light on the right-hand side and round the edges. This will give the illusion that the middle is raised as the light catches it.

9 Using the permanent rose and Winsor blue mix, deepen some of the shadows on the flower heads to give more depth to the form of the flower, using hard and soft edges.

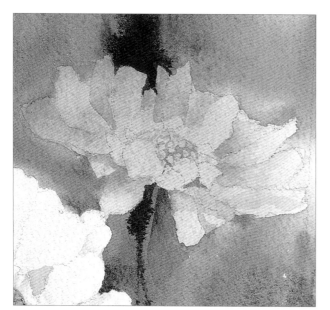

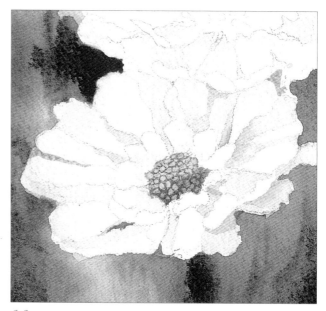

10 Add circles to the centres of the background flowers, making them fainter because too much detail would bring them too sharply into focus.

11 Glaze over the middles of the foreground flowers to warm them, using a mix of lemon yellow and cadmium yellow. After this, you may need to darken the circles a little on the right.

12 The centres of the two main flowers are slightly different. Paint the hollows using a deeper mix of lemon yellow and cadmium yellow, leaving the edges as white paper. At this stage you should stand back and assess the painting, adjusting the depth of colour where necessary.

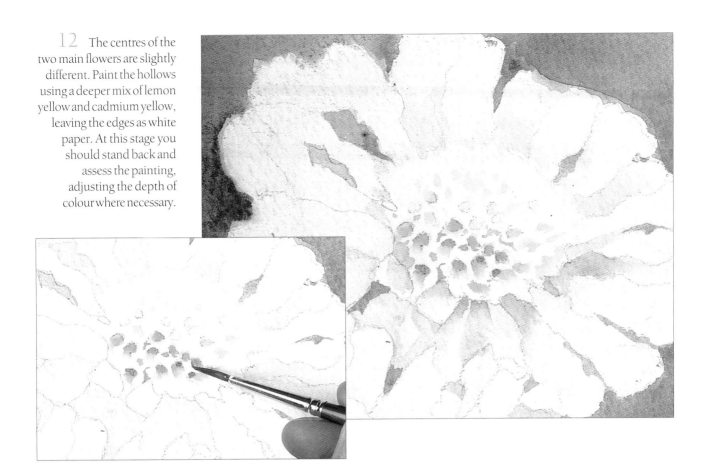

Below: the finished painting

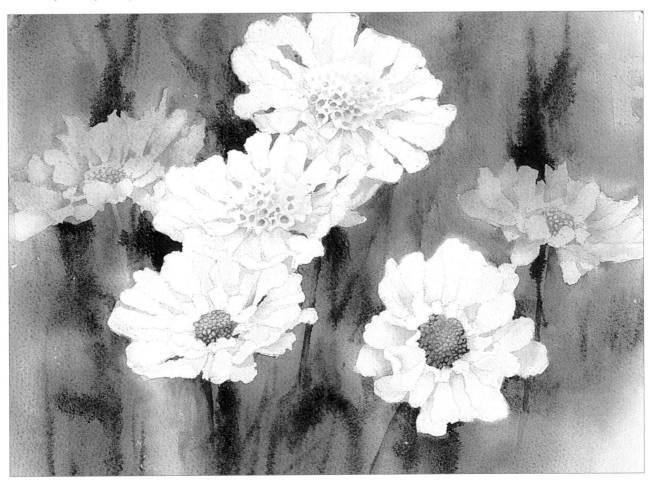

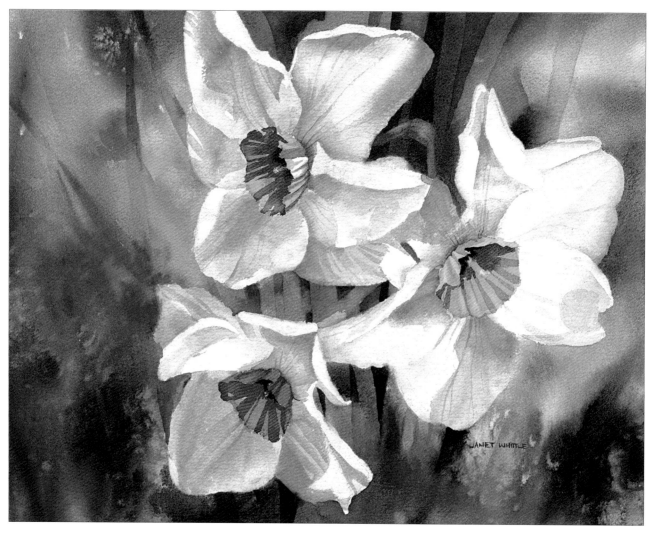

Narcissi

Size: 38 x 38cm (15 x 15in)

After dropping in washes in the background, I sprinkled salt in the wet paint to give a textural effect. If you try this, do not dry your work with a hair dryer, but let it dry naturally. Some colours will give a better result than others, so it is wise to experiment first.

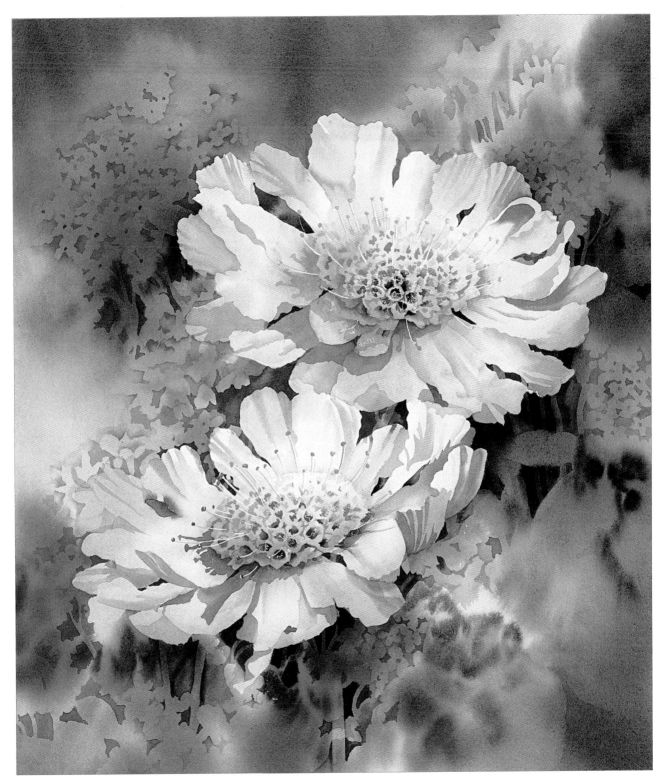

Scabious

Size: 37 x 48cm (14½ x 19in)
I dropped soft washes of colour into the background, then allowed it to dry. Negative shapes were
added to the background to indicate smaller blooms and one or two stalks. The effect was kept
deliberately minimal so the focus of attention would remain on the two main flowers.

Clematis

This demonstration brings together many of the techniques found in this book. If you work through it, referring to previous instructions where necessary, it should help to consolidate your newly-acquired skills.

I used photographs from my archive to plan the composition and produce an outline sketch.

The project is carried out in just four stages: putting in the background; masking the stamens of the flowers (which can be done with a small brush or even a cocktail stick); using negative painting to bring out the detail and putting in the petals wet-in-wet. The colour of the flower has been used in the background to suggest more out-of-focus blooms and buds. Pink is a delicate colour, and to make it more vibrant I have left sunlit areas of white to counterchange the background against it.

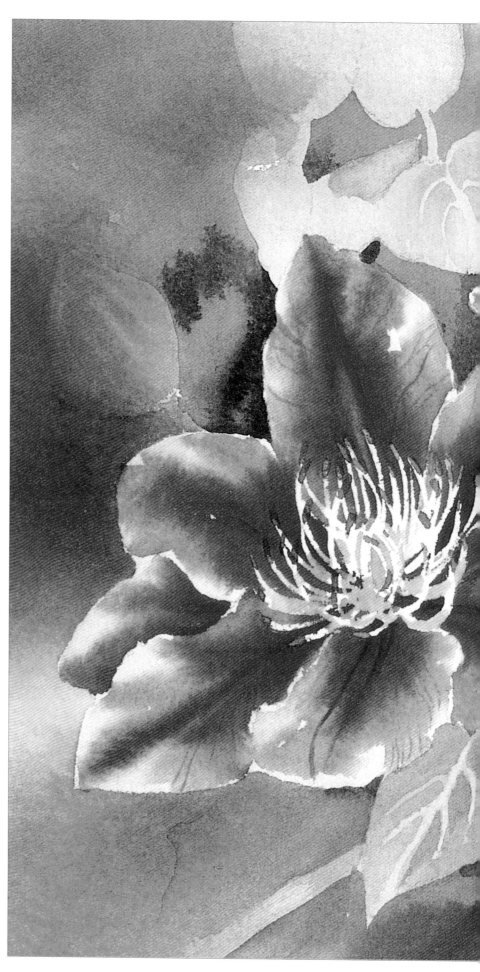

The finished picture
Size: 55 x 38cm (21½ x 15in)
These lovely flowers come in an enormous variety of shapes and hues, so you can change the colours to suit yourself.

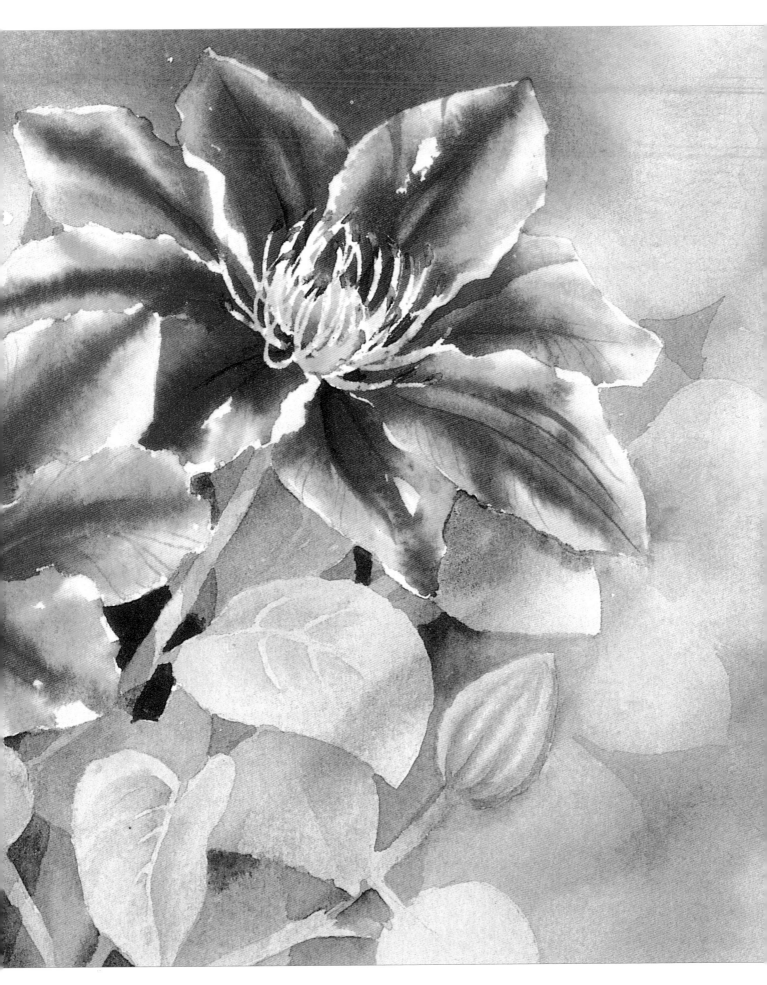

Before you begin, mix up the main colours you will use:

1. Permanent rose and lemon yellow
2. Permanent rose
3. Sap green
4. Cobalt blue
5. Viridian and Winsor blue
6. Viridian and burnt umber
7. Permanent rose and magenta

YOU WILL NEED

Watercolour paper 640gsm (300lb)
3B pencil
Masking fluid and old brush
Round brush No. 6
Rigger No. 3
Large wash brush
Watercolour paints: I used permanent rose; cobalt blue; Winsor blue; viridian; lemon yellow; burnt umber; magenta and sap green

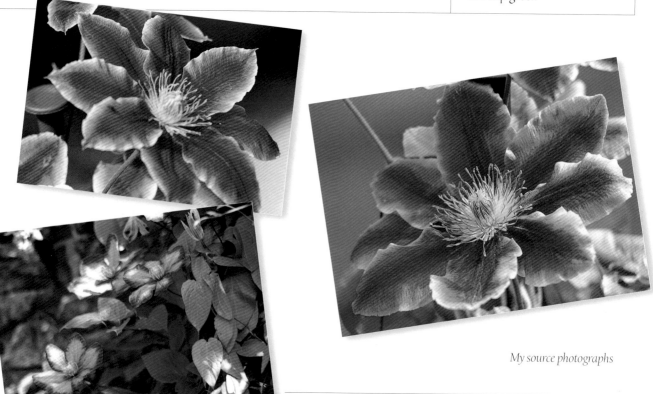

My source photographs

1 Using the large brush, dampen the paper up to the pencilled outlines of the flowers and put in the background, using permanent rose and lemon yellow; permanent rose; sap green, and touches of viridian and Winsor blue. Tip to merge the colours and leave to dry.

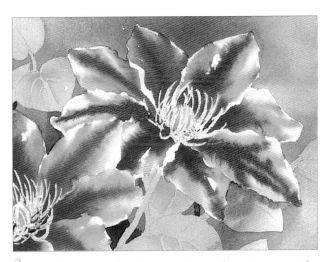

2 Using the No. 6 brush, paint in negative to bring out the leaves and buds using the viridian and burnt umber mix. Leave to dry. Remove the masking fluid at the edges of the flowers, but leave the stamen masked.

3 Wet the white area and paint in the petals wet-in-wet, with the mix of permanent rose. Use a small (No.3) rigger to drop in a darker mix of permanent rose and magenta. Leave areas of white paper to counterchange against the background.

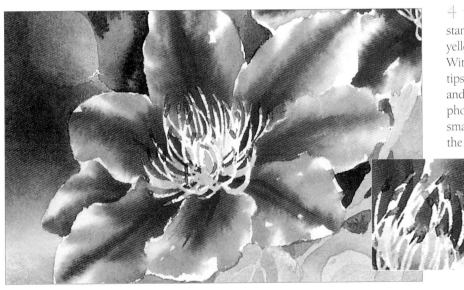

4 Rub off the masking fluid on the stamen and use a pale wash of lemon yellow to push back some of the white. With the small rigger brush, paint in the tips of the stamens using burnt umber and alizarin crimson (see inset photograph). With the cobalt blue and a small rigger brush, add very fine veins to the centre of some of the petals.

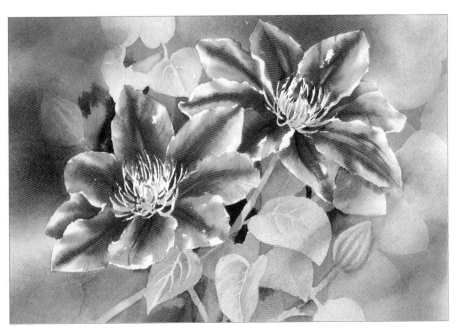

The finished painting

Cosmos

Size: 55 x 38cm (21½ x 15in)
Flowers with an overall 'white' effect often have very little white on them when you come to paint them, as this example shows. I saw these growing in France, and the lavender in the background meant that the composition is about blues, pinks and purples. The shadows on the flower petals capture the effect of sunlight. The veining of the flowers has been darkened within the shadow area.

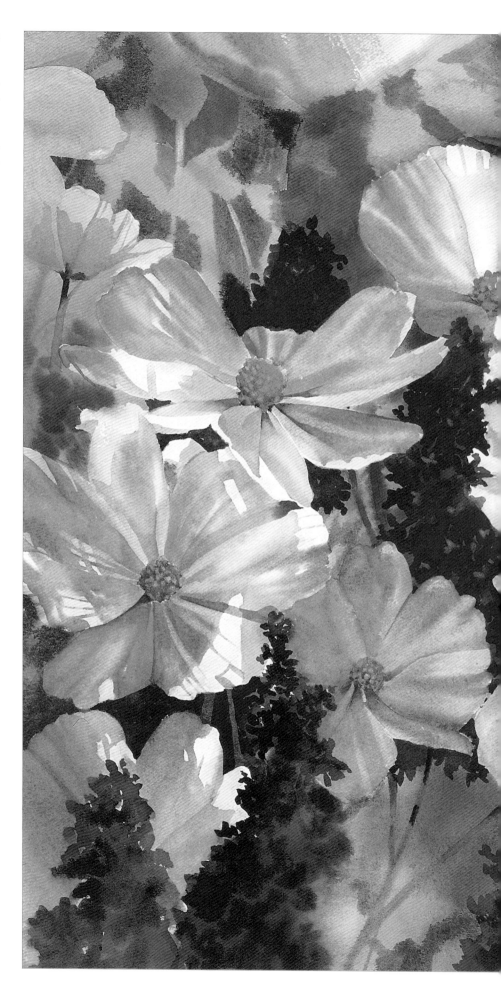

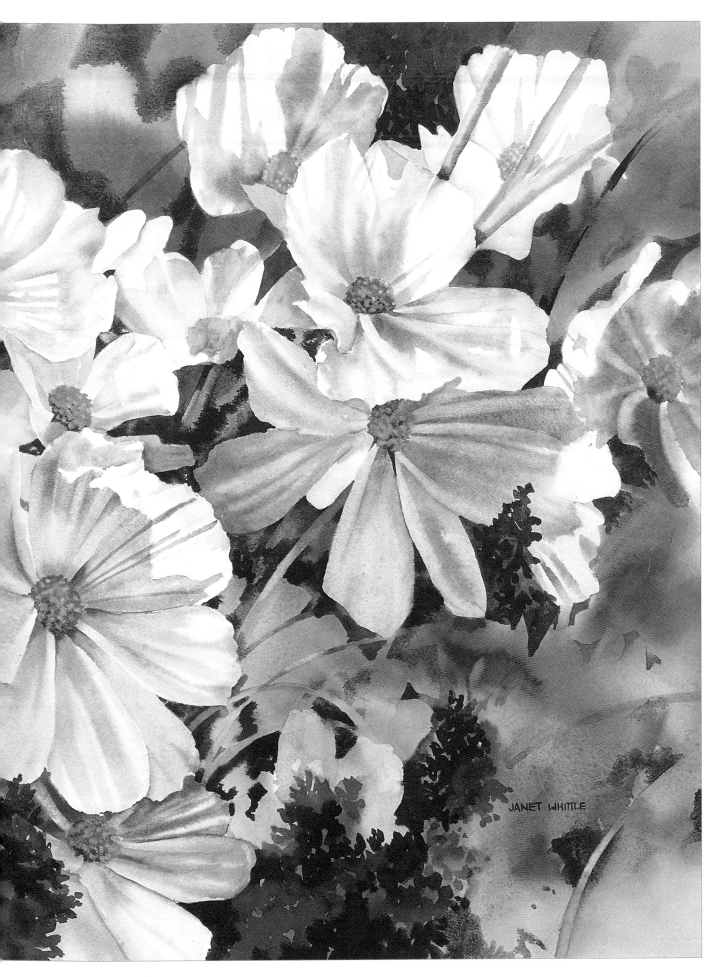

JANET WHITTLE

Index

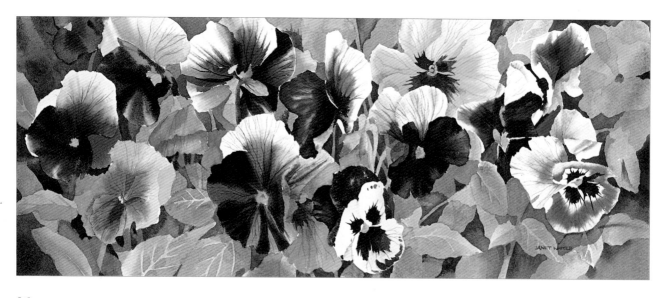